# HOW TO DRAW MANGA

# ILLUSTRATING BATTLES

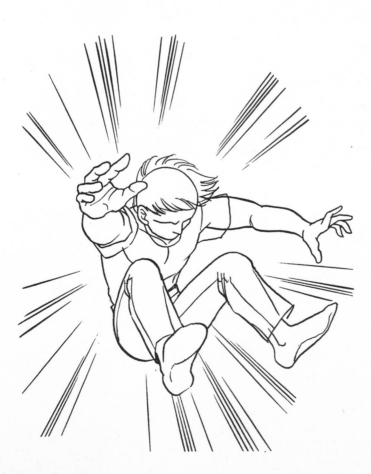

# TABLE OF CONTENTS

# HOW TO DRAW MANGA: ILLUSTRATING BATTLES
by Hikaru Hayashi, Go Office

Copyright © 1998 Hikaru Hayashi, Go Office
Copyright © 1998 Graphic-sha Publishing Co., Ltd.

First designed and published in 1998 by Graphic-sha Publishing Co., Ltd.
This English edition was published in 2000 by Graphic-sha Publishing Co., Ltd.

Planning & Production: Yasuo Matsumoto, Jun Matsubara, Kento Shimazaki, Mirai Murakawa,
Riho Yagizawa, Takehiko Matsumoto, Kazuaki Morita
Cover drawing: Takehiko Matsumomo
Cover CG work: Takashi Nakagawa
Cover design: Hideyuki Amemura
English edition layout: Shinichi Ishioka
English translation: Christian Storms
English translation management: Língua fránca, Inc. (an3y-skmt@asahi-net.or.jp)
Japanese edition editor: Motofumi Nakanishi (Graphic-sha Publishing Co., Ltd.)
Foreign language edition project coordinator: Kumiko Sakamoto (Graphic-sha Publishing Co., Ltd.)

Distributed by
NIPPON SHUPPAN HANBAI INC.
4-3 Kanda Surugadai,
Chiyoda-ku, Tokyo
101-8710 Japan
Tel: +81(0)3-3233-4083
Fax: +81(0)3-3233-4106
E-mail: nippan@netlaputa.ne.jp

Distributed
in North America by
DIGITAL MANGA DISTRIBUTION
1123 Dominguez St., Unit "K"
Carson, CA 90746, U.S.A.
Tel: (310) 604-9701
Fax: (310) 604-1134
E-mail: distribution@emanga.com
URL:http://www.emanga.com/dmd/

First printing:       August 2000
Second printing:   May 2001
Third printing:     August 2001
Fourth printing:    November 2001
Fifth printing:      March 2002
Sixth printing:     August 2002
Seventh printing:  November 2002
Eighth printing:    February 2003
Ninth printing:     March 2003

ISBN: 4-7661-1147-8
Printed and bound in China by Everbest Printing Co., Ltd.

# CHAPTER 1

# DRAWING FIGHTING SCENES THEORY

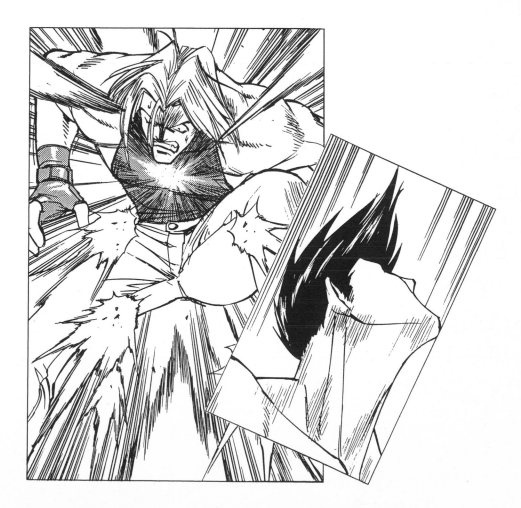

# How to Show Force

**1. Using a Crescendo (<) Mark**
This plain, horizontal drawing is too explanative. Use a crescendo mark, which is shaped like 'ku' in the Japanese phonetic alphabet.

The neck done with a crescendo mark.

POOW

The key to battle action shots is deformity. It is important to make the person who gets hit look like he has really been hit.

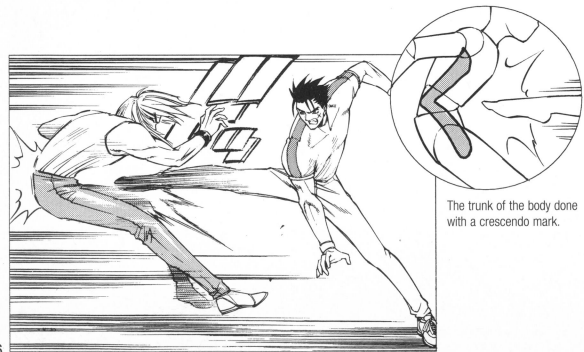

The trunk of the body done with a crescendo mark.

## 2. Using Close-ups

Once the characters' positions have been established, go for a close-up to one side.

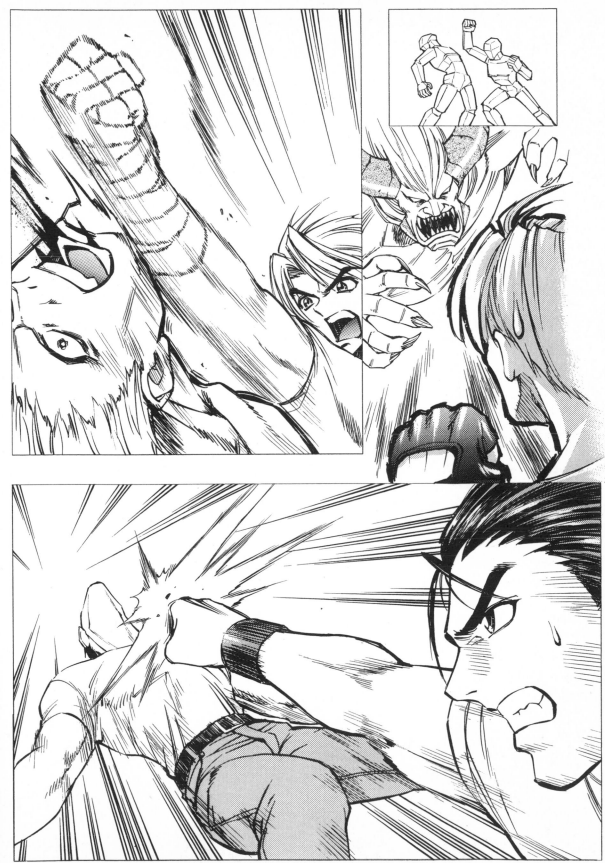

## 3. Conveying the Sensation of Speed

The sensation of speed is added to the force when the fist is expressed with oblique lines.

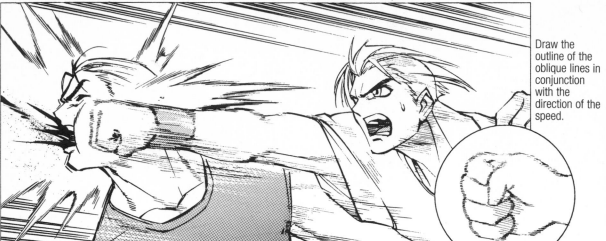

Draw the outline of the oblique lines in conjunction with the direction of the speed.

The arm itself can be used to express the speed's afterimage.

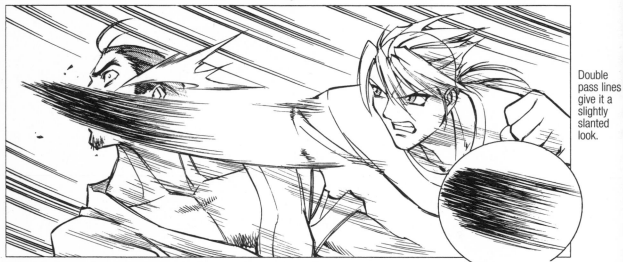

Double pass lines give it a slightly slanted look.

For a sensation of speed too fast for the naked eye, emphasize the locus of the punch with white lines.

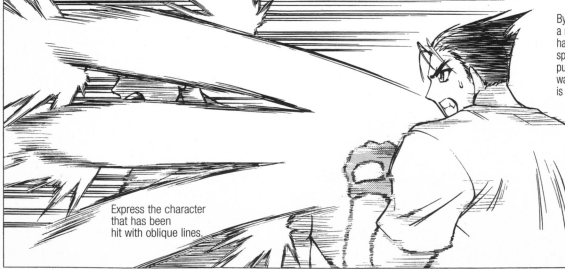

By drawing a retracted hand, the speed of the punch that was delivered is emphasized.

Express the character that has been hit with oblique lines.

## 4. Expressing Hairstyles

Hair can yield effects to the movement and power in the scene. By fluttering the hair or by adding gradation to the head movement, a sense of speed may be expressed.

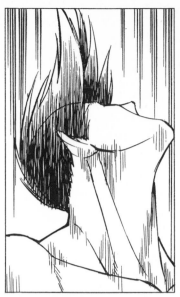

Gradation: used together with double pass lines.

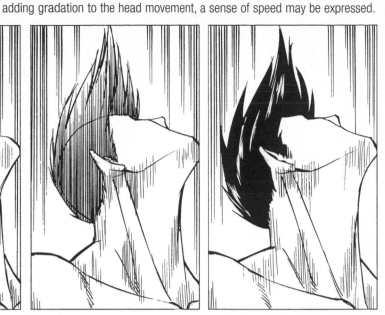

Gradation: speed lines in conjunction with the direction of the effect

Fluttering hair done in normal black.

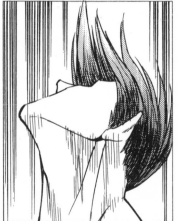

Gradation: with a tone and double pass lines.

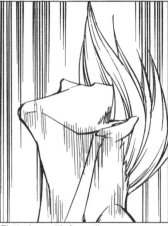

Fluttering: with fewer lines

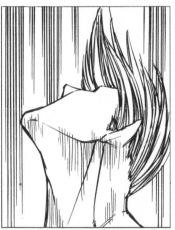

Fluttering: hairlines

### Try this technique to increase the force even more.

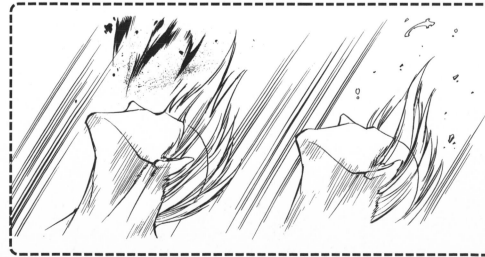

Force and the sensation of speed can be expressed differently based upon the space they are in. Hair that dances in the air and clothing that flutters, as well as flying blood and sweat can become effective items for expression.

flying blood

flying liquids like sweat and spit along with dirt

## 5. Looking at the Opponent - Line of Sight

Whether the character's face is pointing towards the opponent or not, follow the method of not averting the eyes from the opponent in order to bring tense battle scenes to life.

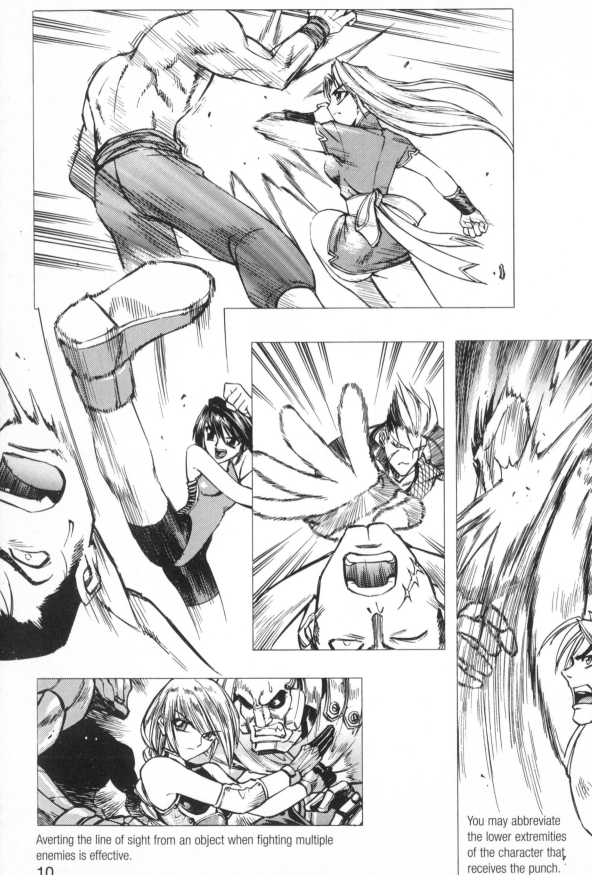

Averting the line of sight from an object when fighting multiple enemies is effective.

You may abbreviate the lower extremities of the character that receives the punch.

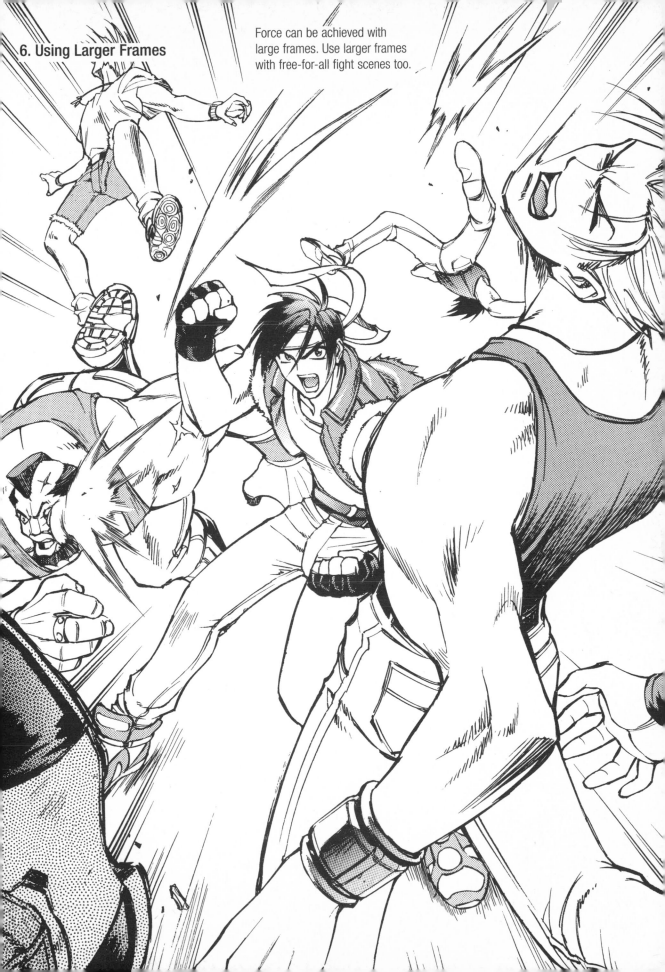

### 6. Using Larger Frames

Force can be achieved with large frames. Use larger frames with free-for-all fight scenes too.

## 7. "Attacked-characters" are the Conclusive Factor in Free-for-all Fight Scenes Too!

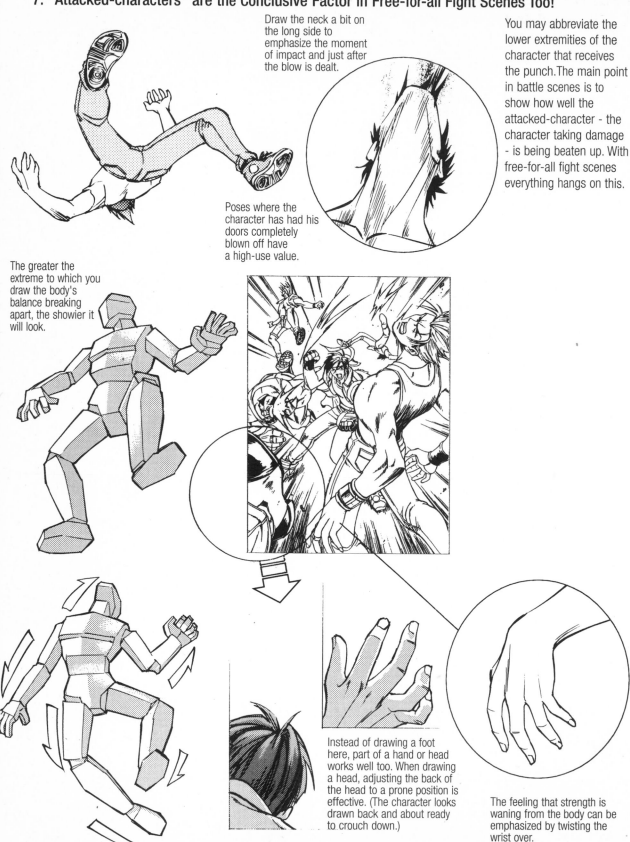

Draw the neck a bit on the long side to emphasize the moment of impact and just after the blow is dealt.

You may abbreviate the lower extremities of the character that receives the punch. The main point in battle scenes is to show how well the attacked-character - the character taking damage - is being beaten up. With free-for-all fight scenes everything hangs on this.

Poses where the character has had his doors completely blown off have a high-use value.

The greater the extreme to which you draw the body's balance breaking apart, the showier it will look.

Instead of drawing a foot here, part of a hand or head works well too. When drawing a head, adjusting the back of the head to a prone position is effective. (The character looks drawn back and about ready to crouch down.)

The feeling that strength is waning from the body can be emphasized by twisting the wrist over.

Draw the body broken up into parts facing different directions to show the performance of an attacked-character that has been beaten up and lost his balance.

# Try Changing the Pose of the Central Character Without Changing the Opponent Characters

The size of the foot is about the same size as the head being kicked.

- The way the back of the foot shown changes depending on the kicking style.
- Kicking style variations can be expressed with the way the backside of the foot is drawn.

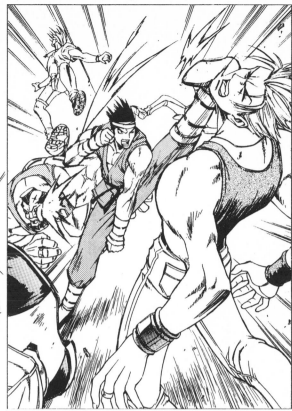

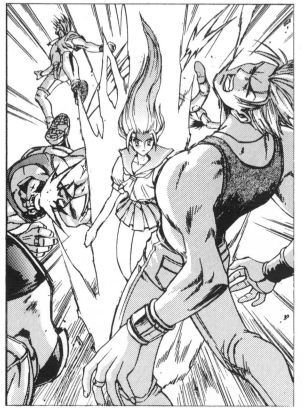

The above example illustrates psychic energy being released by the central character.

## Views on Attacked-characters and Knocked-out Characters

When drawing a character that has been completely blown away, consider the direction of force in which the character was impacted (i.e. what area of the body and at what angle).

Draw a circle around the character.

Drawing large and small images - regardless of the distance/perspective - of the character's fists letting out bursts of energy makes for a cool effect.

One central focal point is enough.

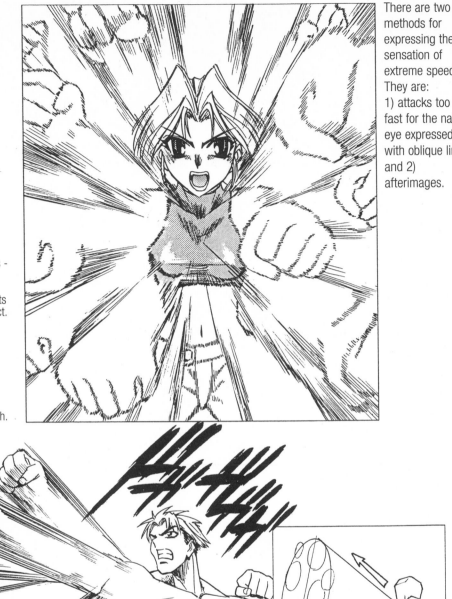

There are two methods for expressing the sensation of extreme speed. They are:
1) attacks too fast for the naked eye expressed with oblique lines and 2) afterimages.

When drawing several punches delivered by one arm, the shoulder should be the central focal point as it releases the energy.

Don't draw images possessing a speed that cannot be captured with a camera or on film with solid lines.

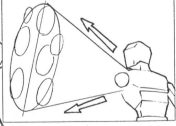

The central focal point changes with each punch.

## 9. Drawing Many Sections 2 — Conveying the sensation of speed with the attacked-character

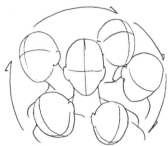

Draw the character in a neutral position at first.

By moving the upper-body and neck, the range which the head that can move becomes quite large.

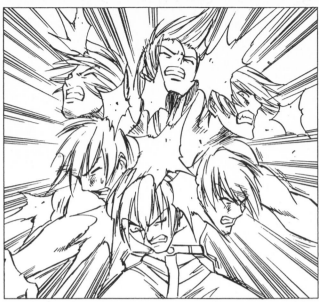

Hint: draw lots of marks like this.

- Draw the heads all the same size.
- Make sure the head doesn't stray too far away from the torso.

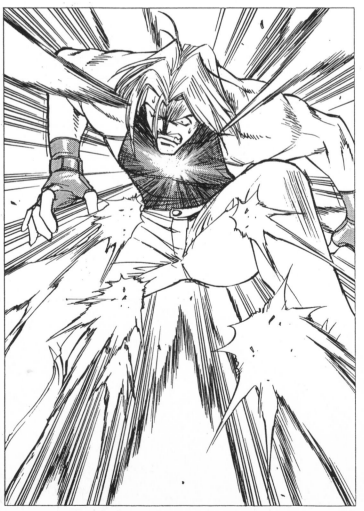

### Head Angles From Different Ways Punched

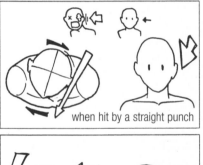

when hit by a straight punch

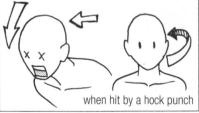

when hit by a hock punch

The head turns according to the angle and direction in which it was attacked.

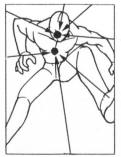

When expressing repeated blows, choose only one focal point. This should either be the middle of the head or the chest.

# Knock-out Patterns
## Theory Composition

### 1. Drawing the Knocked-out Character's Feet in the Foreground

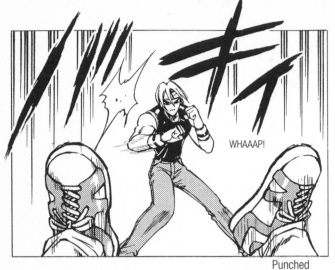

WHAAAP!

Punched

Drawing a portion of the knocked-out-character's body in the foreground can be applied in various scenes.

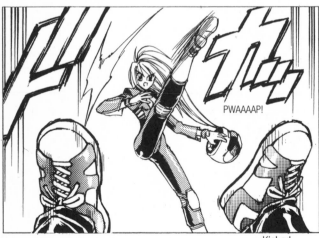

PWAAAAP!

Kicked

Variations of the Attacking Side: Wooden Sword

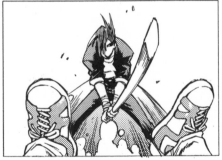

Blow delivered by a rock

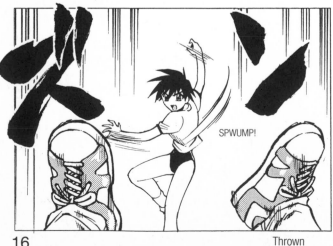

SPWUMP!

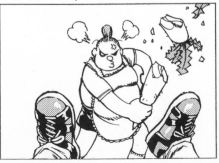

Thrown

A Japanese radish...it really doesn't matter what you use.

## 2. Drawing the Knocked-out Character's Head in the Foreground

Hand Variations

A shot right after impact. Even if the means and steps are different, the meaning of the visual effect does not change.

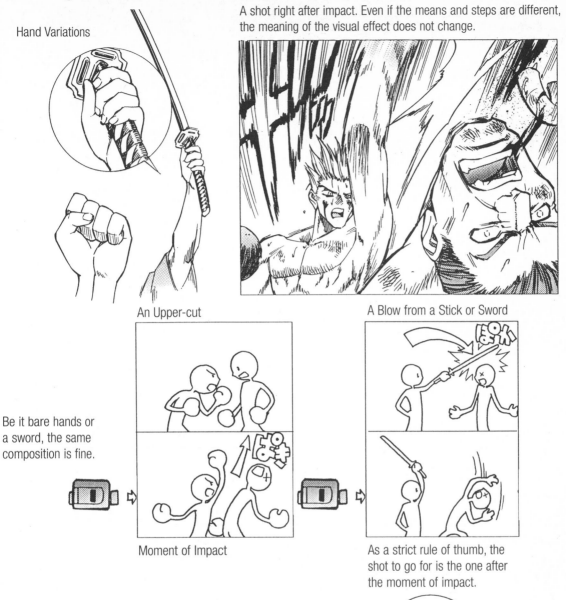

An Upper-cut

A Blow from a Stick or Sword

Be it bare hands or a sword, the same composition is fine.

Moment of Impact

As a strict rule of thumb, the shot to go for is the one after the moment of impact.

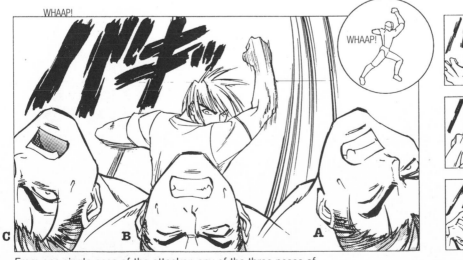

WHAAP!

WHAAP!

C    B    A

From one single pose of the attacker, any of the three poses of the character that was attacked can be used.

# Expressing Swollen Faces

Express blows, swelling, bruises and the like with oblique lines and tones.

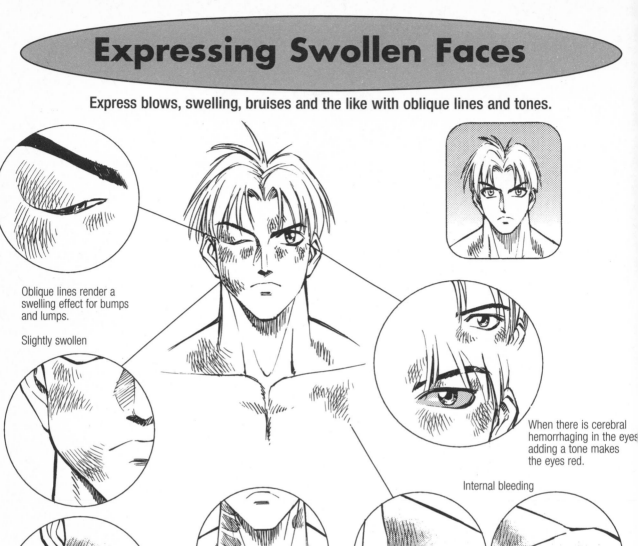

Oblique lines render a swelling effect for bumps and lumps.

Slightly swollen

When there is cerebral hemorrhaging in the eyes adding a tone makes the eyes red.

Internal bleeding

Extremely swollen

Internal bleeding resulting after having the neck strangled. Adding oblique lines makes the area look bruised.

Lacerations from a blade or knife should be sharp.
This has been composed with the curved lines drawn along the curved facial sections.

When showing close-ups add tones on top of the oblique lines to express red and black-and-blue swelling.

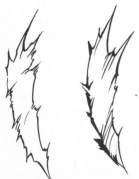

Lacerations from a dull blade or knife should be wild looking. Adding a shadow emphasizes the wildness.

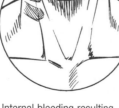

Old wound

Manipulate the width of the lines when you want to show a slight bit of swelling.

Expressing gaze and bandages

# CHAPTER 2

# DRAWING BLOWS: PUNCHES, KICKS AND SLAPS

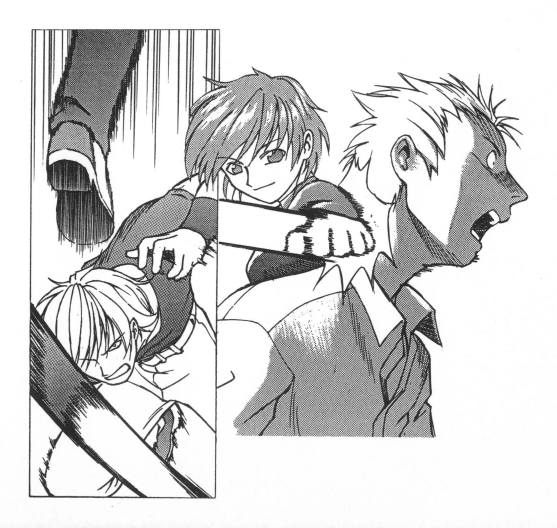

# Drawing Attacked-characters

Consider the direction of force (i.e. the direction of the punches and kicks delivered) and the area of impact when drawing the pose of attacked-characters.

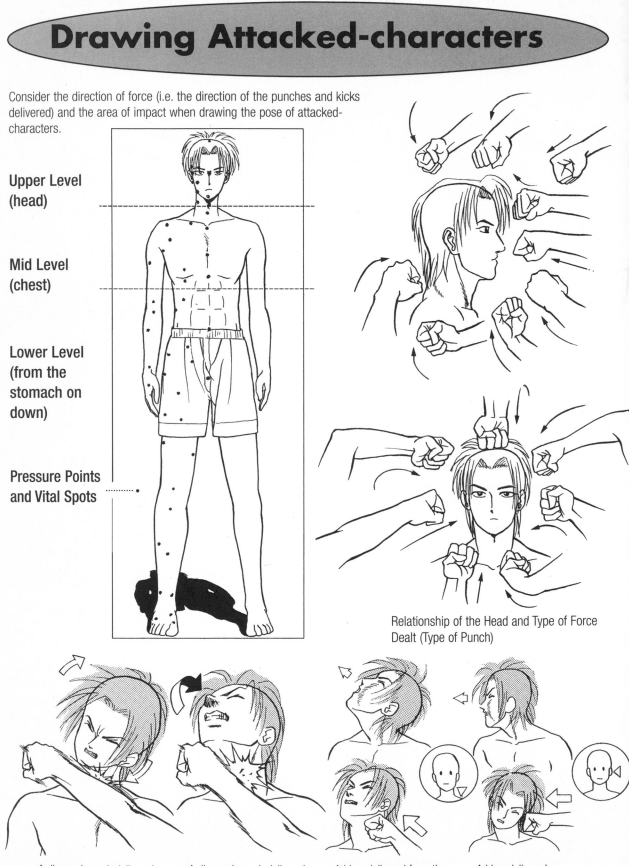

**Upper Level (head)**

**Mid Level (chest)**

**Lower Level (from the stomach on down)**

**Pressure Points and Vital Spots**

Relationship of the Head and Type of Force Dealt (Type of Punch)

A diagonal punch delivered from below that grazes the chin yields the above result.

A diagonal punch delivered from below yields the above result.

A blow delivered from the side (i.e. an angle somewhere in between a hook and cross punch).

A blow delivered squarely from the side (i.e. hook punch).

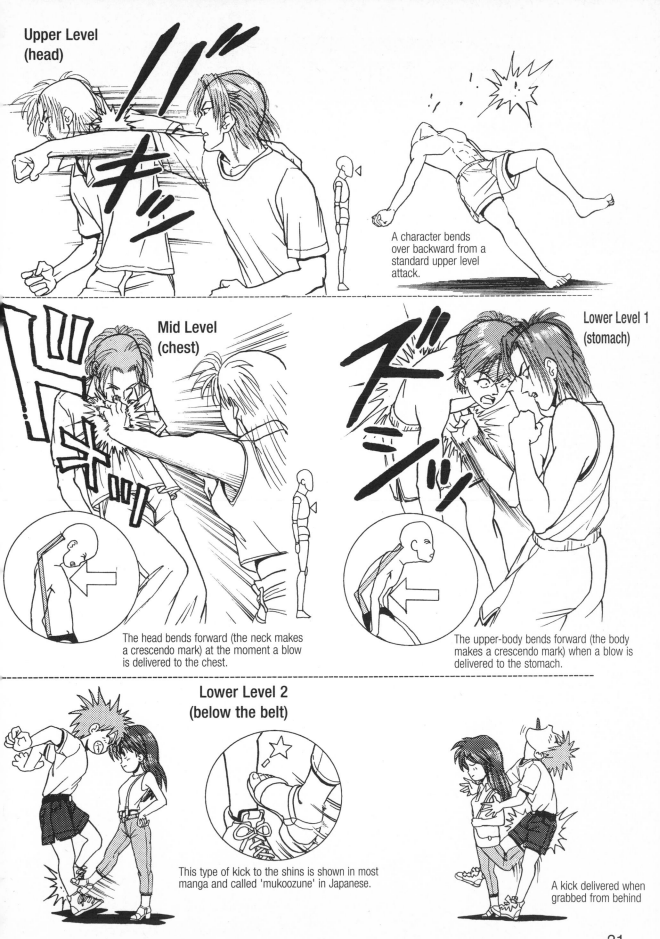

**Upper Level (head)**

A character bends over backward from a standard upper level attack.

**Mid Level (chest)**

The head bends forward (the neck makes a crescendo mark) at the moment a blow is delivered to the chest.

**Lower Level 1 (stomach)**

The upper-body bends forward (the body makes a crescendo mark) when a blow is delivered to the stomach.

**Lower Level 2 (below the belt)**

This type of kick to the shins is shown in most manga and called 'mukoozune' in Japanese.

A kick delivered when grabbed from behind

# Upper Level Attacks

## 1. Punching Square in the Face

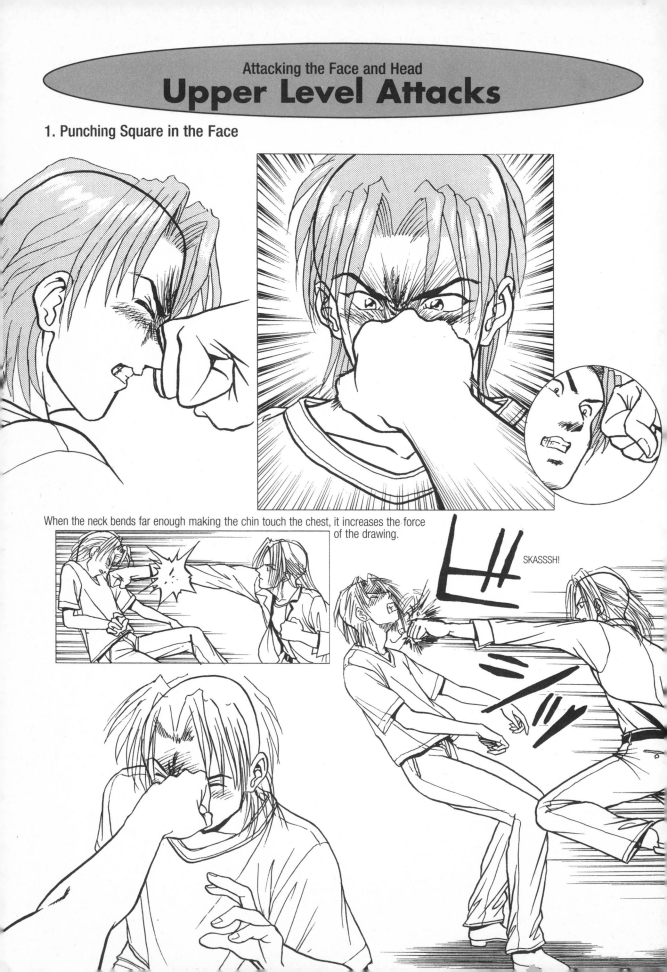

When the neck bends far enough making the chin touch the chest, it increases the force of the drawing.

SKASSSH!

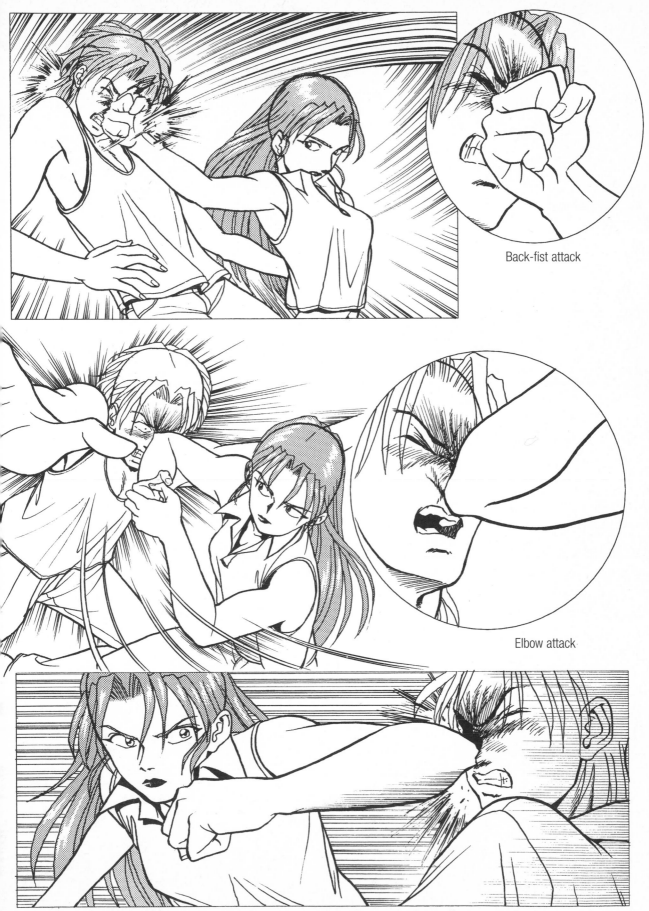

Back-fist attack

Elbow attack

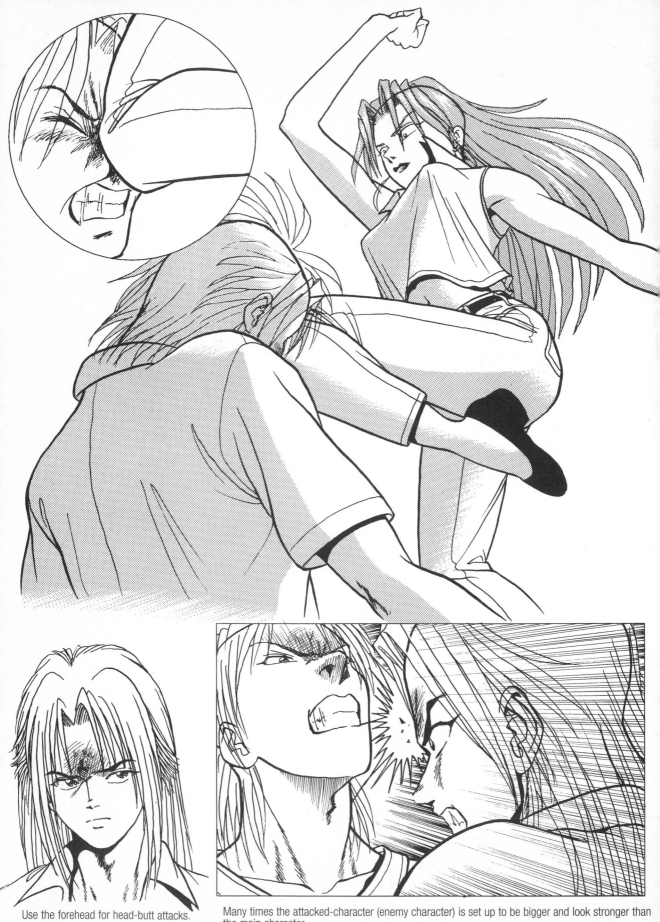

Use the forehead for head-butt attacks.

Many times the attacked-character (enemy character) is set up to be bigger and look stronger than the main character.

24

Contrasting objects like cars, desks, etc., add visual direction to height and width in an open space.

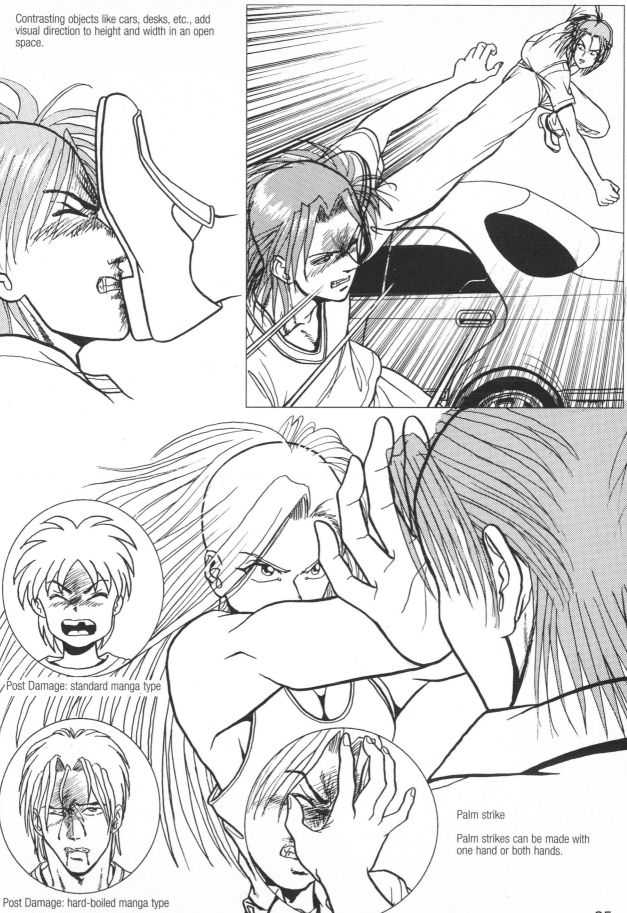

Post Damage: standard manga type

Post Damage: hard-boiled manga type

Palm strike

Palm strikes can be made with one hand or both hands.

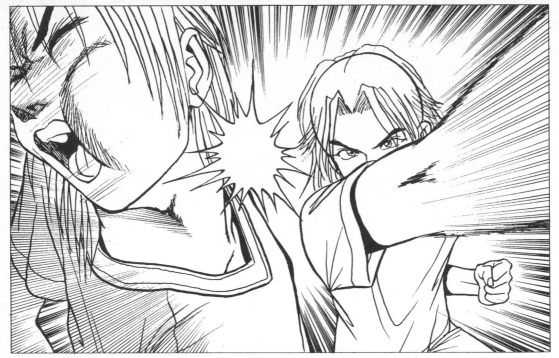

## 2. Attacking Diagonally from Below and Upward

Changing the direction of the attacked-character's face and torso can emphasize the speed of the punch.

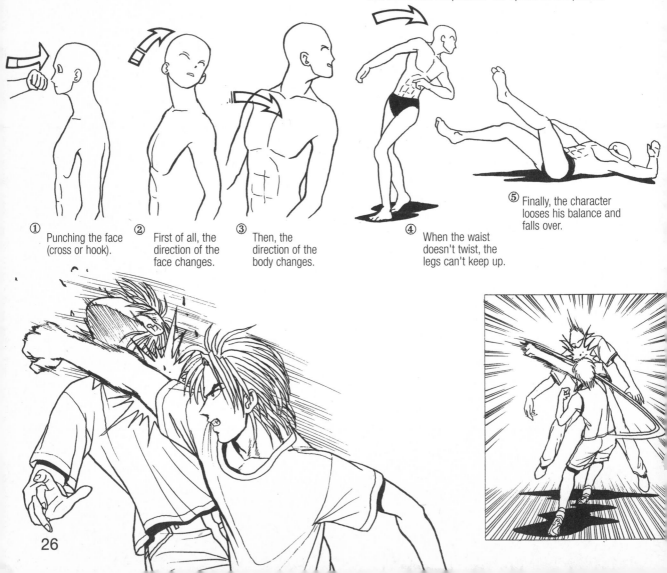

① Punching the face (cross or hook).

② First of all, the direction of the face changes.

③ Then, the direction of the body changes.

④ When the waist doesn't twist, the legs can't keep up.

⑤ Finally, the character looses his balance and falls over.

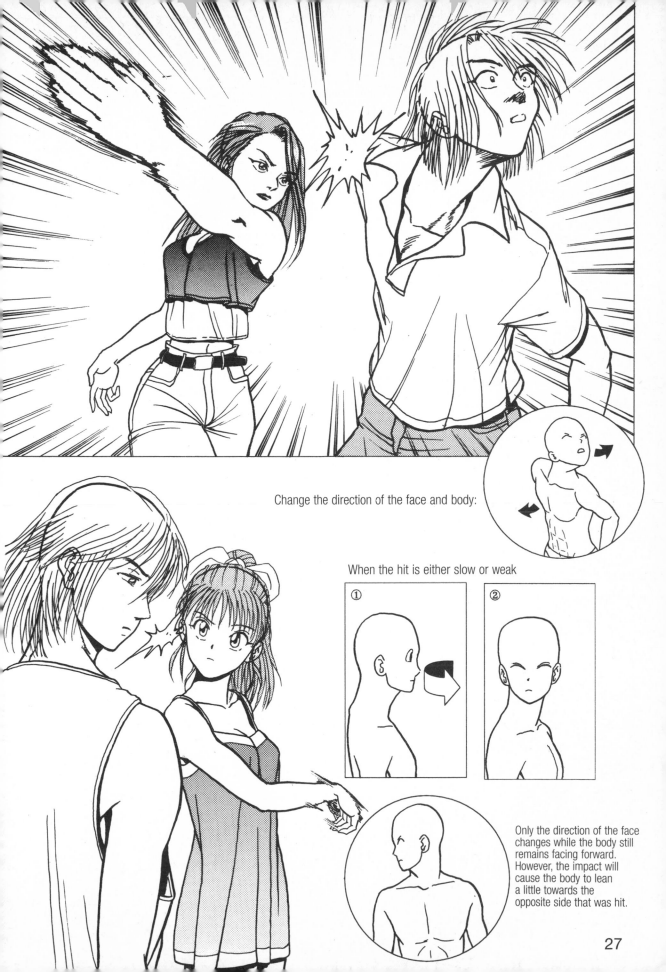

Change the direction of the face and body:

When the hit is either slow or weak

① ②

Only the direction of the face changes while the body still remains facing forward. However, the impact will cause the body to lean a little towards the opposite side that was hit.

## 3. Upper-cuts

Draw the attacked-character's neck a little on the long side.

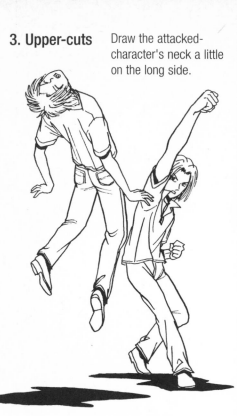

A long, wind-up variation. Bending the attacked-character's body like a bow, lets the reader imagine that the blow delivered to the chin was powerful enough to raise the entire weight of the body.

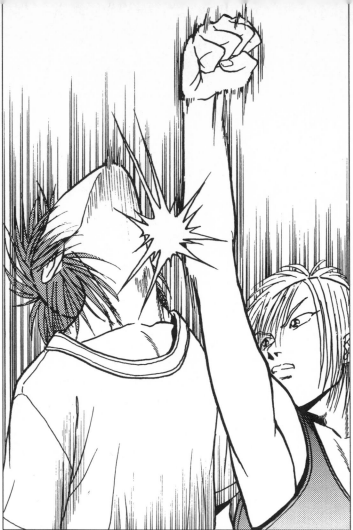

Be sure and show the attacked-character's jaw even if attacked directly from the side.

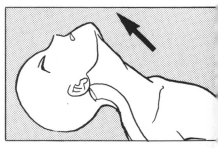

Showing the side of the face gives the impression that the blow was delivered diagonally instead of from below.

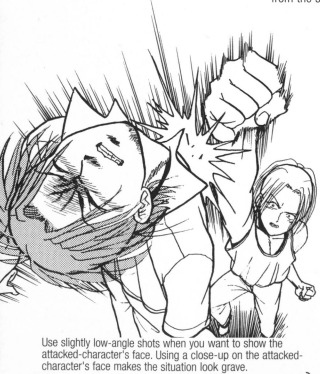

Use slightly low-angle shots when you want to show the attacked-character's face. Using a close-up on the attacked-character's face makes the situation look grave.

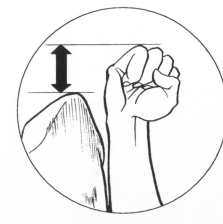

Drawing the fist above the jaw can better show the force of the uppercut.

"Harite" Variations
They are called various things -
bear punch, open-palm punch
- depending on the fighting
style.

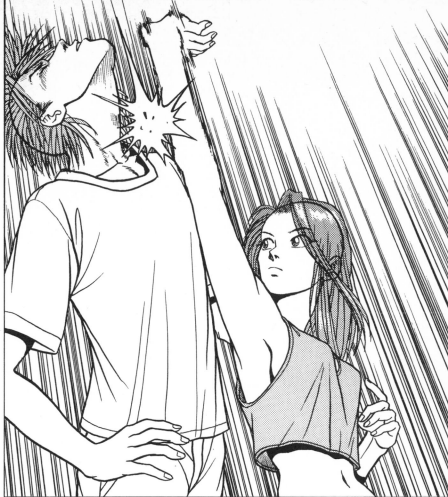

Sumo Slap - 'Harite' in Japanese - Variation

Fist Variations

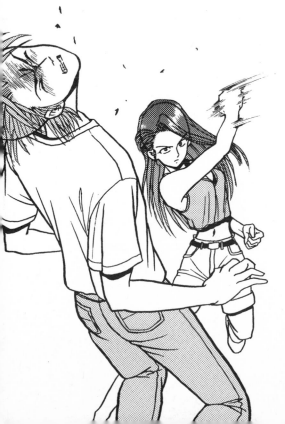

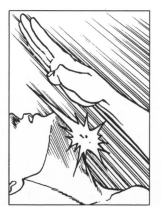

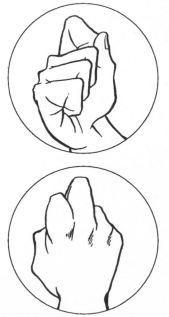

These drawings look like techniques used
in karate or kung fu. Upward thrusting
chops are quite brutal and not often used.

## 4. Kicking to The Head - Upper Level Kicks

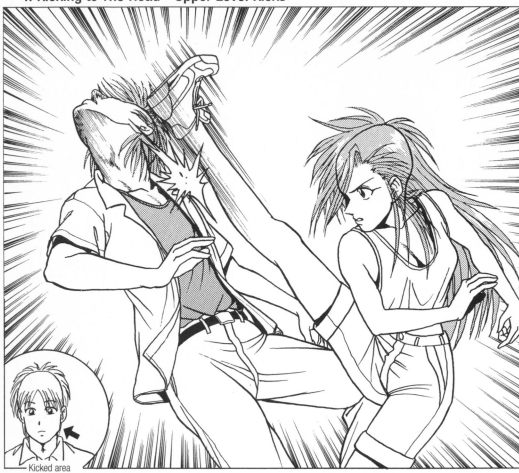

Kicked area

There are a variety of kicks depending on the target (face, chin/jaw, side of the head, back of the head, etc.) and circumstances. In manga, according to your taste, the effect lines vary by the types of kicks delivered.

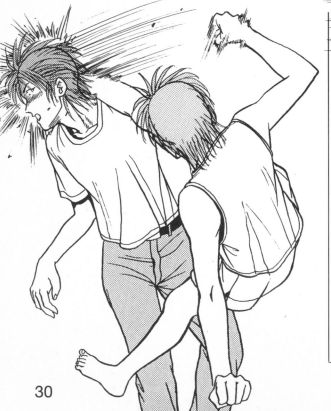

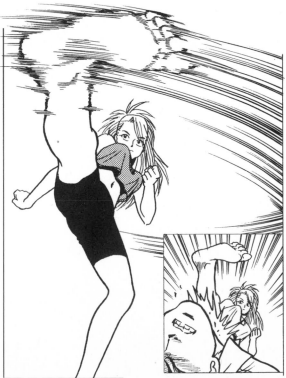

- Curved effect lines - for round-house and spinning kicks
- Straight effect lines - for straight-line kicks (front kicks and sidekicks)

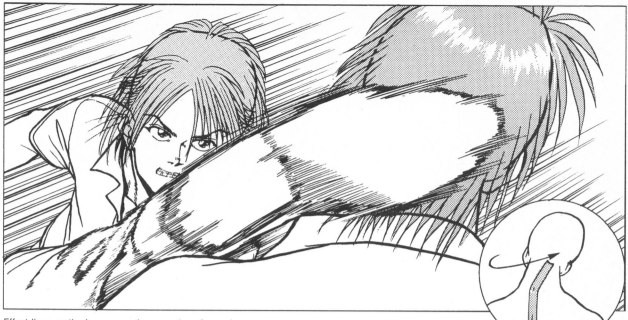

Effect lines on the leg convey the sensation of speed.

Bending the line a little from the ankle to the tiptoe makes the kick look sharp.

Drawing curved effect lines results in a downward heel kick.

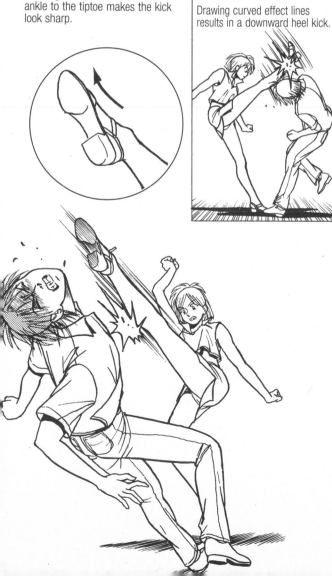

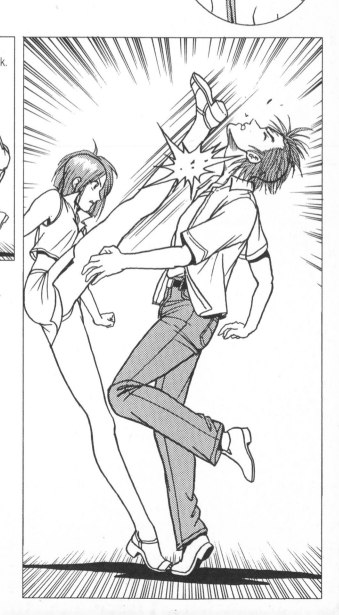

## 5. Punched Faces - Front View

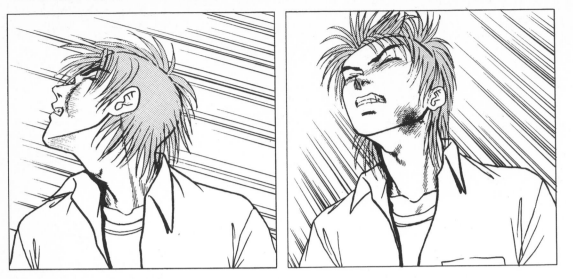

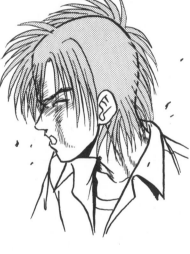

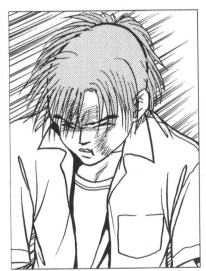

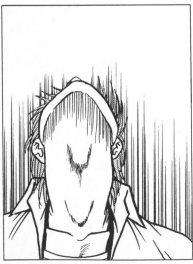

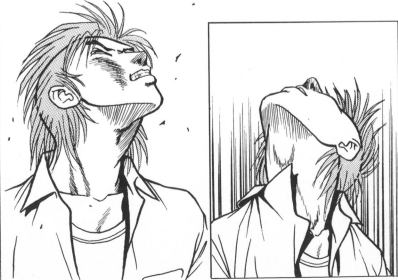

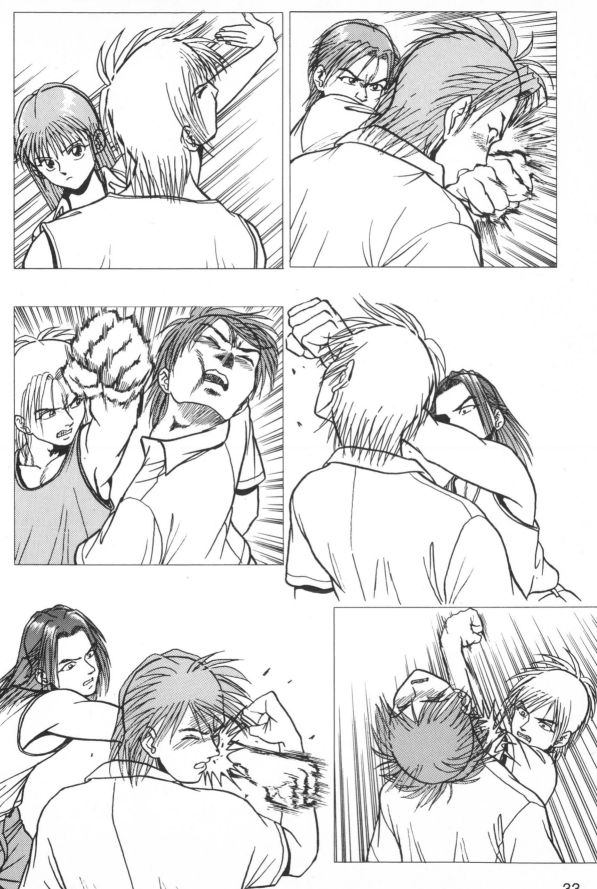

# The Knack of Drawing Realistic Punches

Bad example ✗

If the head, torso and waist are all in the same direction (i.e. no twisting in the lower extremities), the body won't look like it is punching.

Good example ○

Twisting the waist and leaning the body forward creates a 'punching' atmosphere.

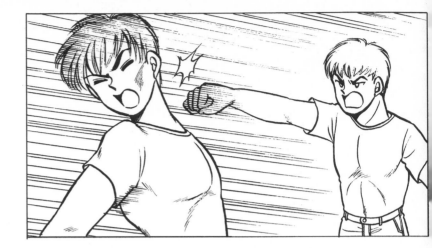

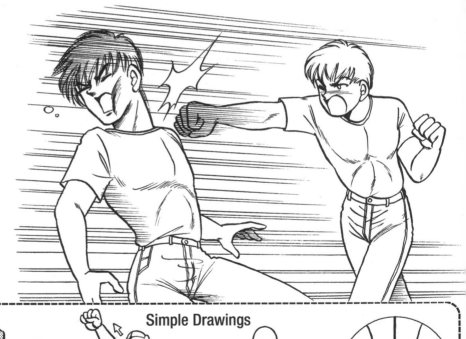

## Simple Drawings

Punching means putting the character's weight into it. Leaning the character forward renders the sense of the character punching with all his might.

Head and waist facing in the same direction (top)
head and upper-body facing in the same direction (bottom)

The body faces in a different direction than the waist. This makes the waist look twisted.

Waist facing forward

## Simple Ways to Draw

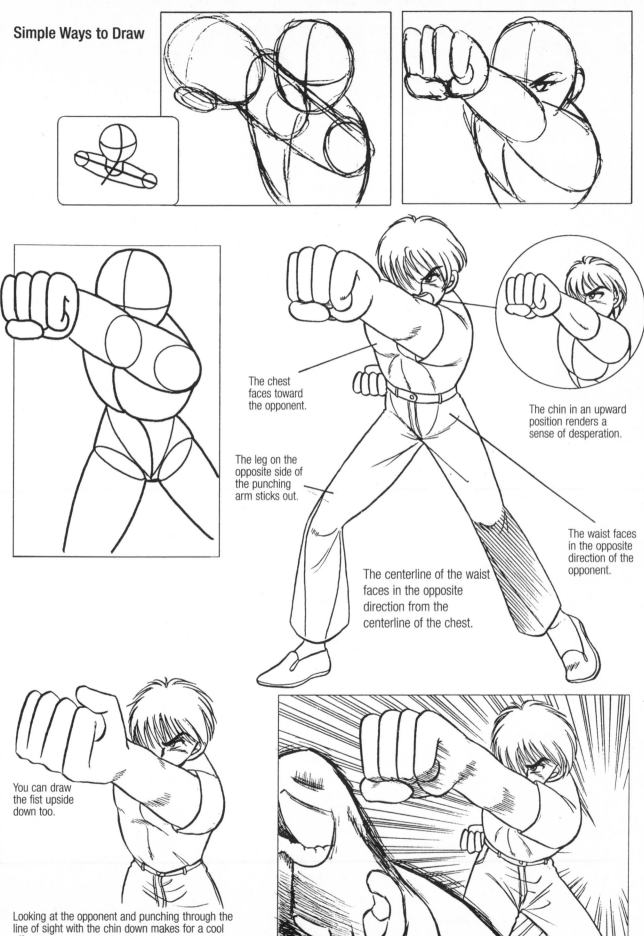

The chest faces toward the opponent.

The chin in an upward position renders a sense of desperation.

The leg on the opposite side of the punching arm sticks out.

The waist faces in the opposite direction of the opponent.

The centerline of the waist faces in the opposite direction from the centerline of the chest.

You can draw the fist upside down too.

Looking at the opponent and punching through the line of sight with the chin down makes for a cool effect.

# Slapping

## 1. Basic Variations

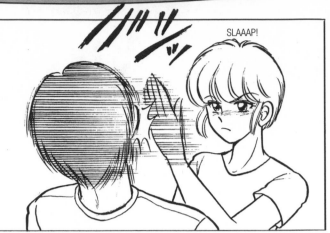

SLAAAP!

There is not a lot of tension before and after the slap. By drawing the line between the neck and shoulder in a natural position, you can express a natural, neutral body position.

The hair swinging creates the sense of being suddenly slapped.

WHAP! WHAP!

Draw the head with a slightly low-angle for back-and-forth (multiple) slaps.

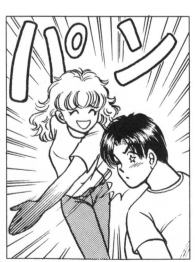

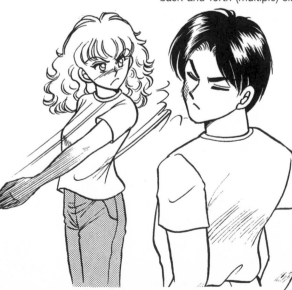

You can draw a pose where the character's waist doesn't twist by making the central lines of the body straight.

Twisting the waist makes the character look like she is accustomed to slapping people.

Not twisting the waist and having the character slap creates a mood.

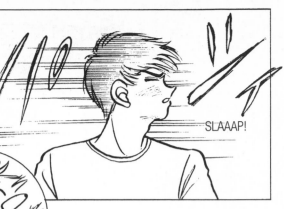

SLAAAP!

The hair swinging creates the sense of being suddenly slapped. Draw the neck a little on the long side when the head swings directly to the side. This works for both serious scenes and comedy.

A downward diagonal slap creates a more serious mood. Expressions facing downward emphasize the 'deep meaning' of the scene.

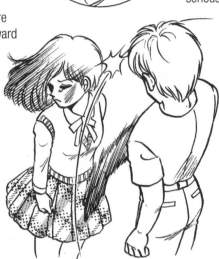

Draw the 'hit mark' in the position where the head was.

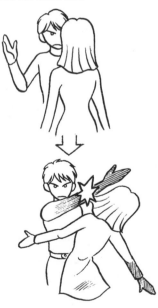

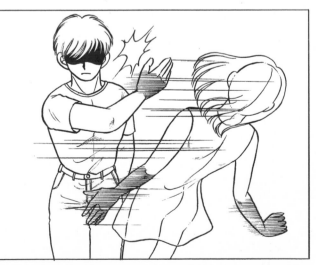

For violent slaps, the character gets mowed down to one side while the direction of the face and body remain facing forward. This is slightly different from standard punches and kicks.

## 2. Striking with the Palm of the Hand

Striking downward

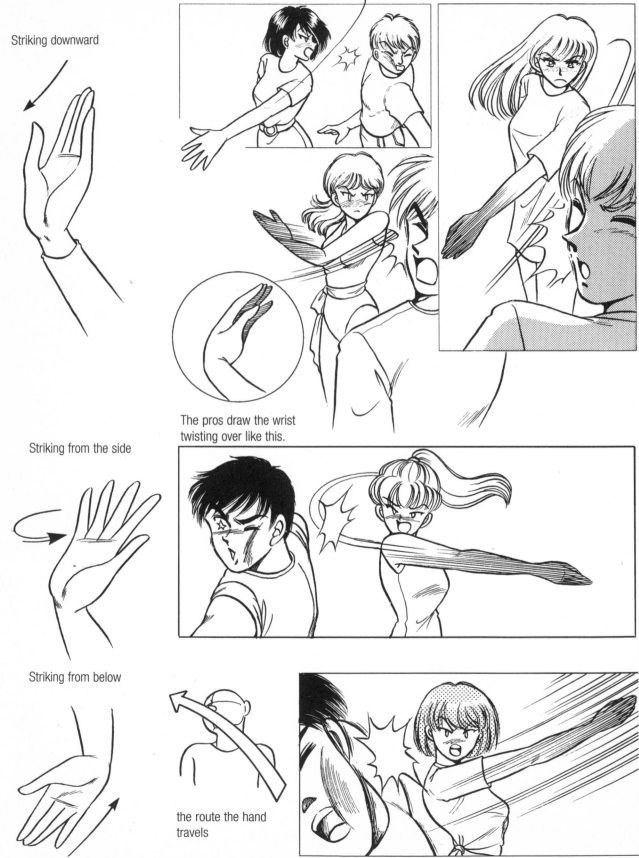

The pros draw the wrist twisting over like this.

Striking from the side

Striking from below

the route the hand travels

Draw a slightly low-angle facing the chin upward.

## Series of Shots

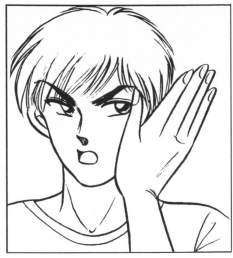

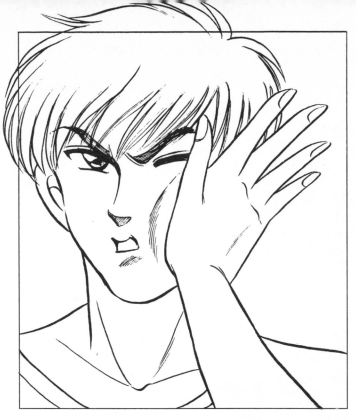

1) Right before impact - The line of sight looks towards the hand.

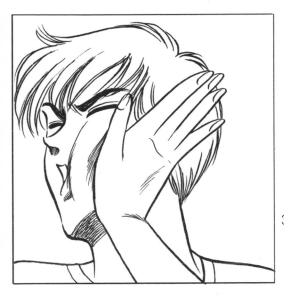

2) Moment of impact - One of the eyes gets pressed closed. You can draw both eyes closed too.

3) While being hit - To make it look like a slap, don't raise the shoulder of the attacked-character.

4) Aftermath - Keep the cheek that has been pushed by the hand as is.

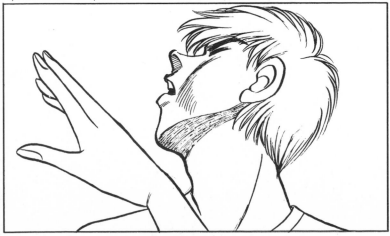

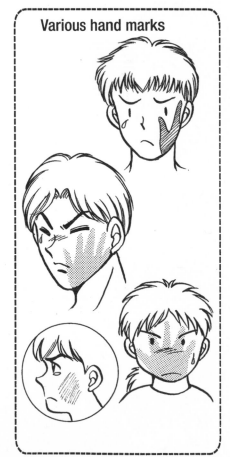

**Various hand marks**

# 3. Slapping with the Back of the Hand

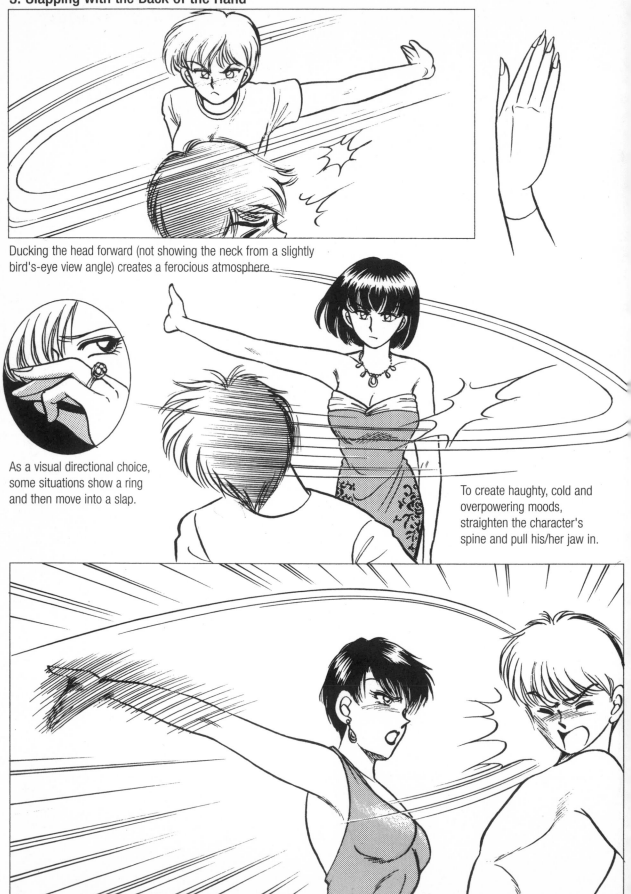

Ducking the head forward (not showing the neck from a slightly bird's-eye view angle) creates a ferocious atmosphere.

As a visual directional choice, some situations show a ring and then move into a slap.

To create haughty, cold and overpowering moods, straighten the character's spine and pull his/her jaw in.

## 4. Back-and-forth (Multiple) Slaps

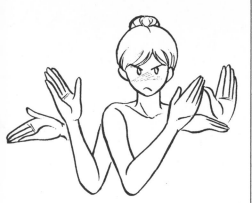

The wrist snaps with multiple slaps.

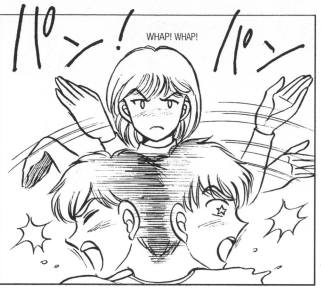

WHAP! WHAP!

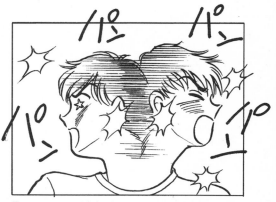

To express multiple slaps use hit points and text.

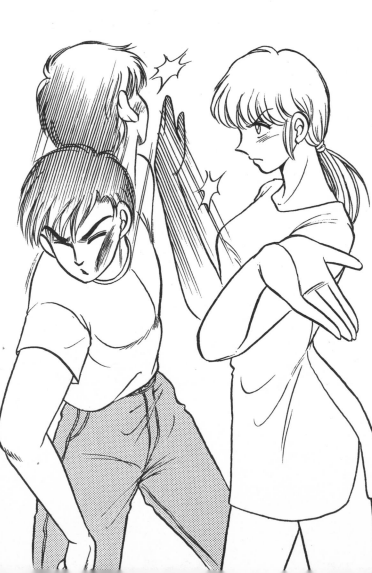

Comedy/Gag Variation: Teeth are missing.

Serious Variation:
A close-up on this
area with a busted lip
is a standard visual
direction choice.

# Striking the Mid Level Area and Chest

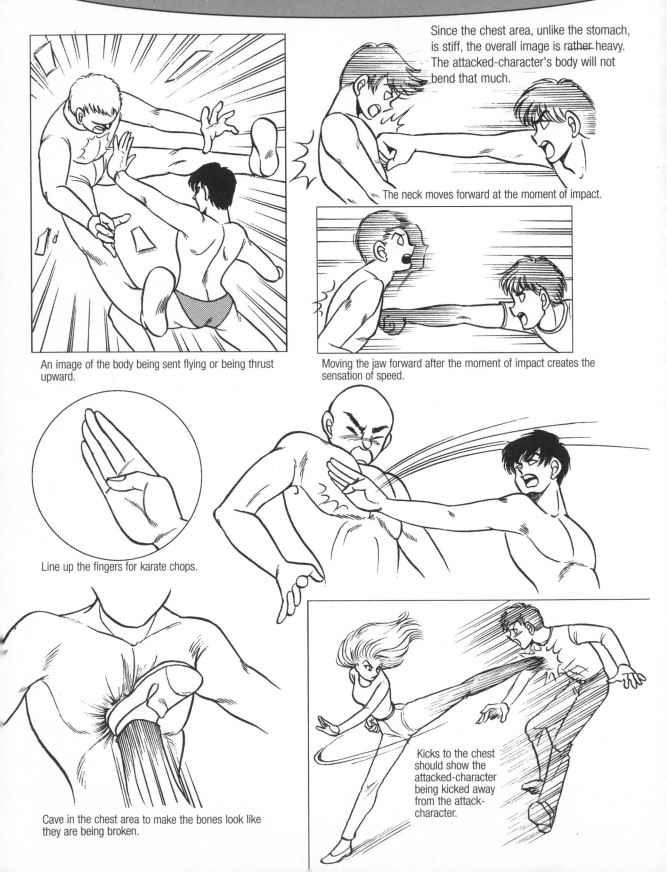

Since the chest area, unlike the stomach, is stiff, the overall image is rather heavy. The attacked-character's body will not bend that much.

The neck moves forward at the moment of impact.

An image of the body being sent flying or being thrust upward.

Moving the jaw forward after the moment of impact creates the sensation of speed.

Line up the fingers for karate chops.

Cave in the chest area to make the bones look like they are being broken.

Kicks to the chest should show the attacked-character being kicked away from the attack-character.

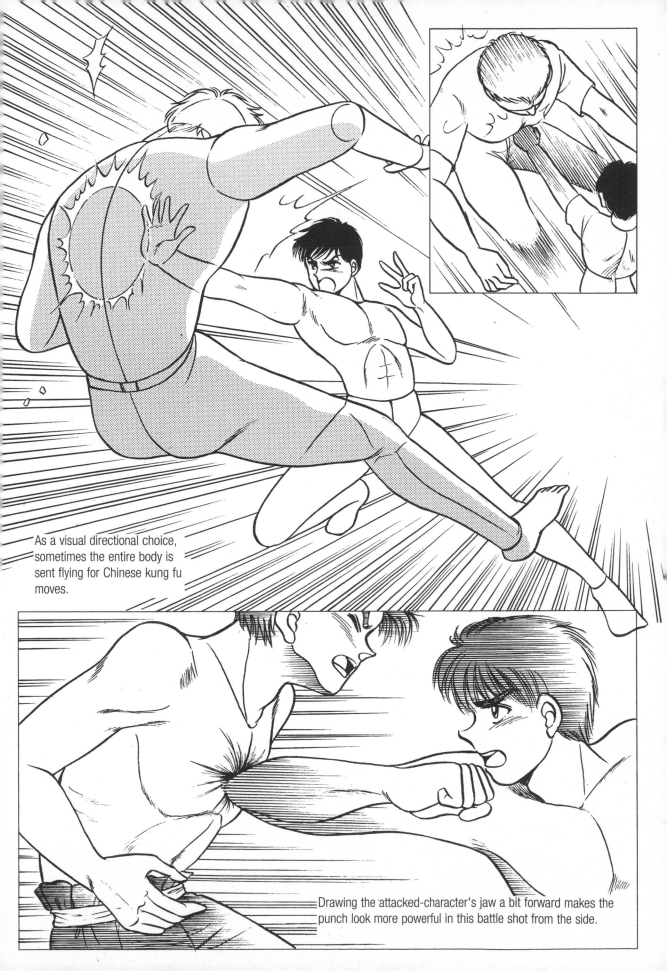

As a visual directional choice, sometimes the entire body is sent flying for Chinese kung fu moves.

Drawing the attacked-character's jaw a bit forward makes the punch look more powerful in this battle shot from the side.

# Attacks to the Pit of the Stomach and Chest

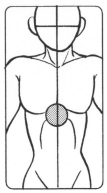

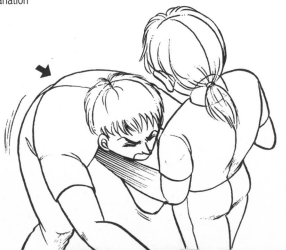

The trick is to include the wrinkles and the caved-in stomach.

While the pit of the stomach is technically located in the upper chest area (represented by the circle) and the stomach is located in the lower area of the body, their use in visual direction for attacked-characters in manga is pretty much the same.

Kneeing Variation

Characteristics of attacked-characters:

1) the body stoops forward forming a crescendo mark
2) the back rounds

By showing the attacked-character's back from a slightly bird's-eye view angle, the strength of the force from the attack-character can be expressed.

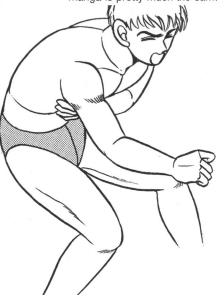

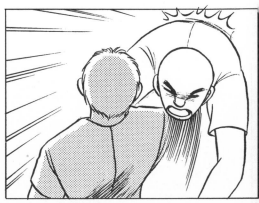

Blows are often times expressed by only using effect-lines.

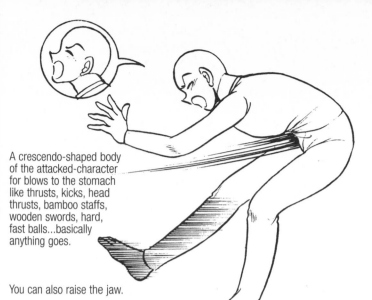

A crescendo-shaped body of the attacked-character for blows to the stomach like thrusts, kicks, head thrusts, bamboo staffs, wooden swords, hard, fast balls...basically anything goes.

You can also raise the jaw.

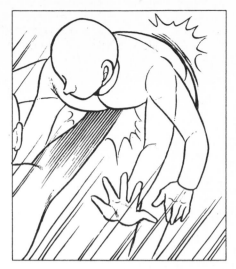

When the character is punched hard in the stomach, the arms move forward from the side.

Practical applications of crescendo-shaped bodies

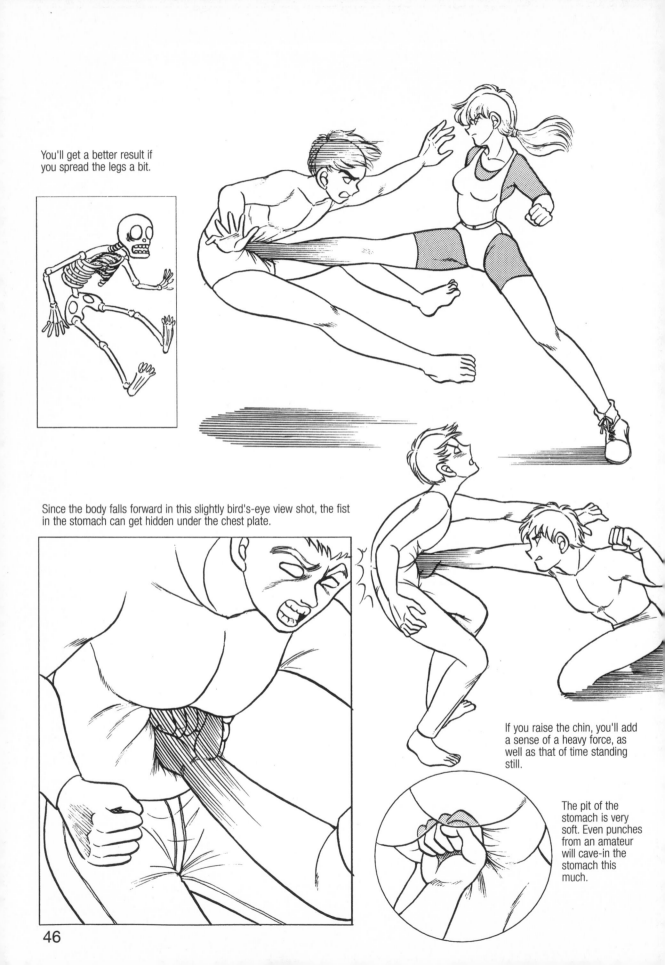

You'll get a better result if you spread the legs a bit.

Since the body falls forward in this slightly bird's-eye view shot, the fist in the stomach can get hidden under the chest plate.

If you raise the chin, you'll add a sense of a heavy force, as well as that of time standing still.

The pit of the stomach is very soft. Even punches from an amateur will cave-in the stomach this much.

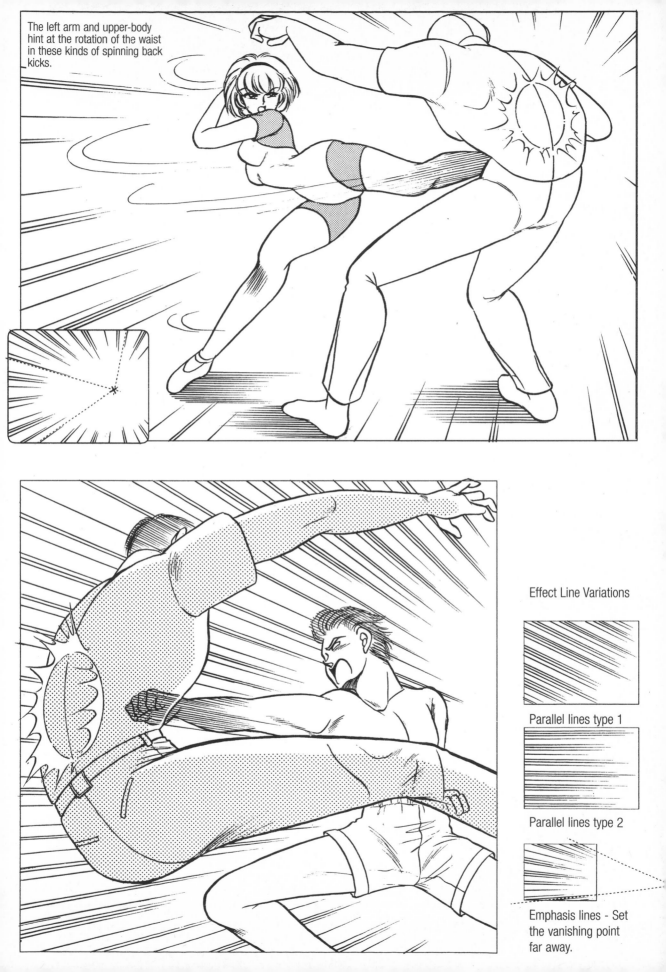

The left arm and upper-body hint at the rotation of the waist in these kinds of spinning back kicks.

Effect Line Variations

Parallel lines type 1

Parallel lines type 2

Emphasis lines - Set the vanishing point far away.

# Attacking Opponents Bent Forward
## Striking Downward

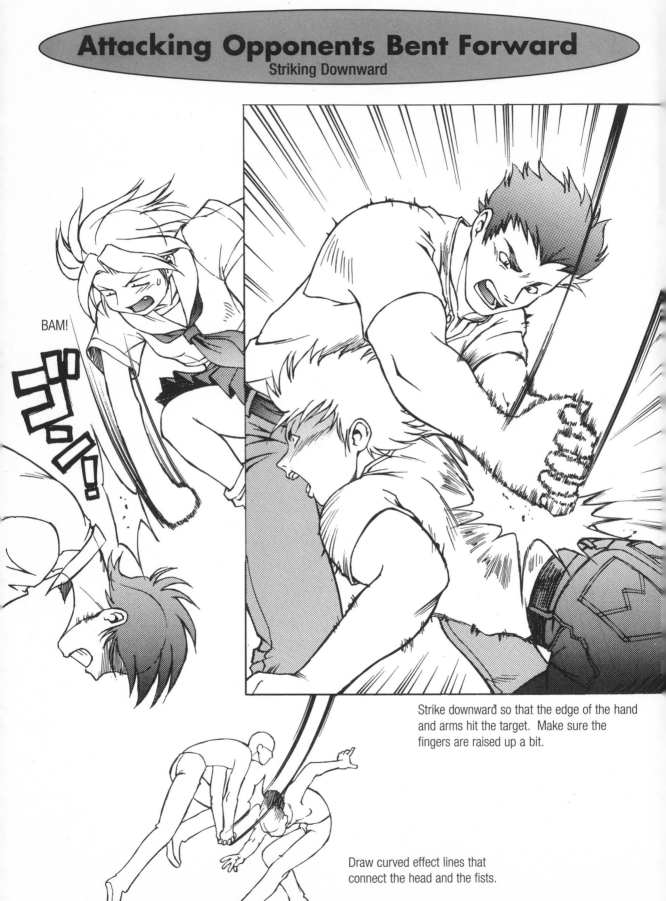

BAM!

Strike downward so that the edge of the hand and arms hit the target. Make sure the fingers are raised up a bit.

Draw curved effect lines that connect the head and the fists.

There are a variety of hand and arm positions when striking downward.

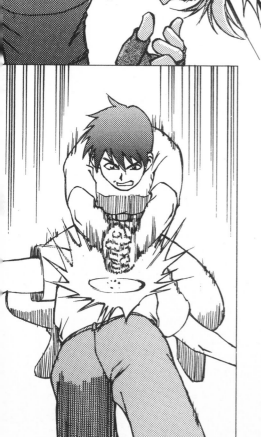

Note: Be it a blow from the fist or elbow or karate chop, the scene will not change much.

The legs can be abbreviated so you don't need to draw them in detail.

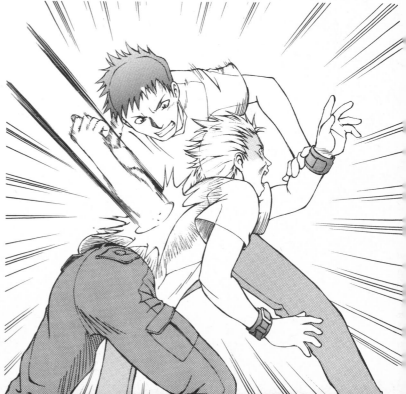

# Lariat Strikes

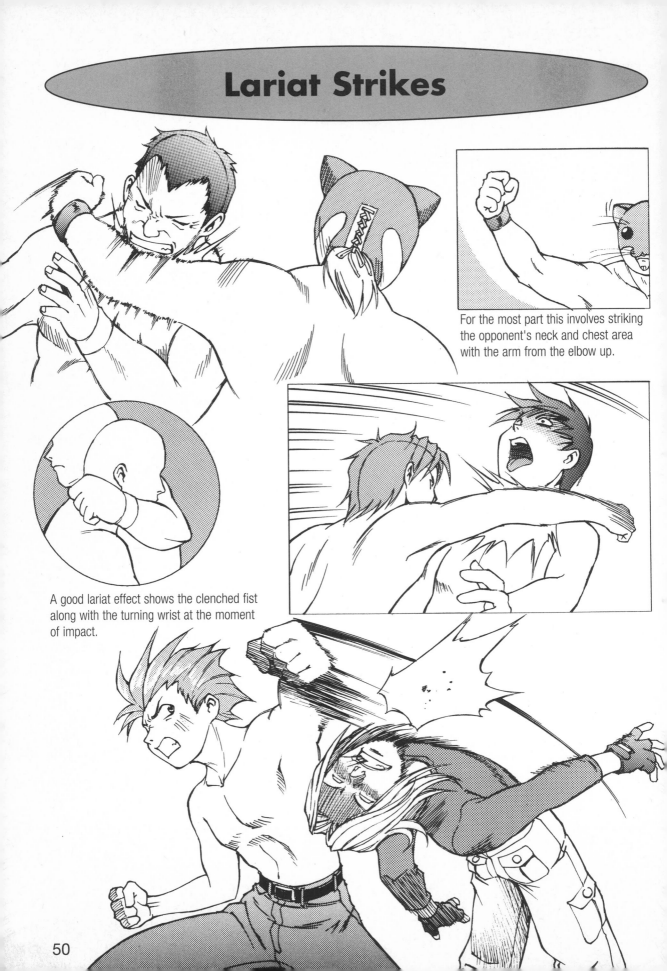

For the most part this involves striking the opponent's neck and chest area with the arm from the elbow up.

A good lariat effect shows the clenched fist along with the turning wrist at the moment of impact.

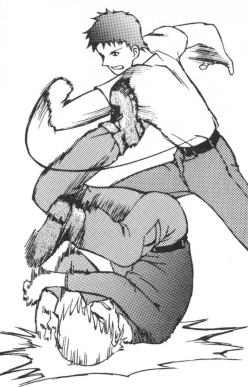

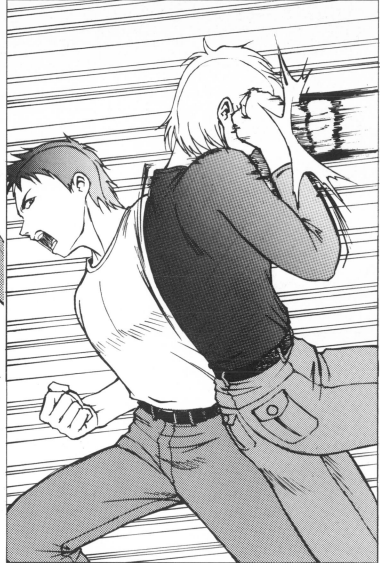

The character is thrown far away.

As a visual direction choice in manga, the neck can be entrapped in the arm and then flung away.

when thrown against a wall

# Hand Chops

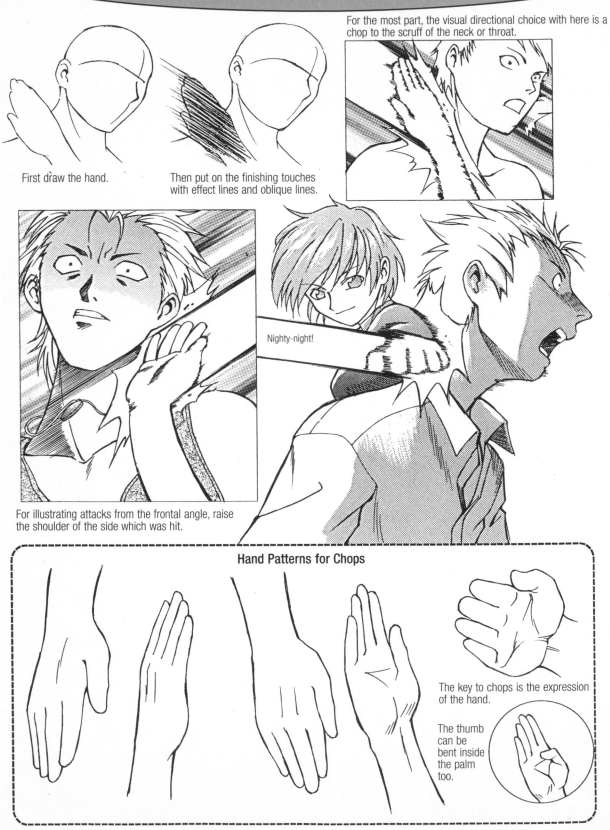

First draw the hand.

Then put on the finishing touches with effect lines and oblique lines.

For the most part, the visual directional choice with here is a chop to the scruff of the neck or throat.

Nighty-night!

For illustrating attacks from the frontal angle, raise the shoulder of the side which was hit.

### Hand Patterns for Chops

The key to chops is the expression of the hand.

The thumb can be bent inside the palm too.

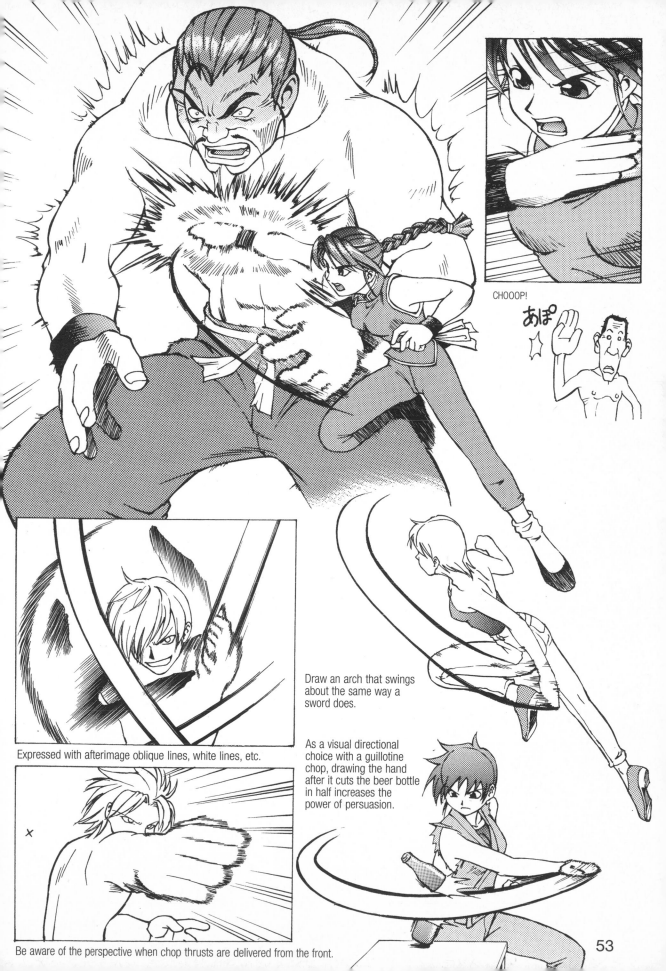

CHOOOP!

あぽ

Draw an arch that swings about the same way a sword does.

Expressed with afterimage oblique lines, white lines, etc.

As a visual directional choice with a guillotine chop, drawing the hand after it cuts the beer bottle in half increases the power of persuasion.

Be aware of the perspective when chop thrusts are delivered from the front.

# Elbows and Knees

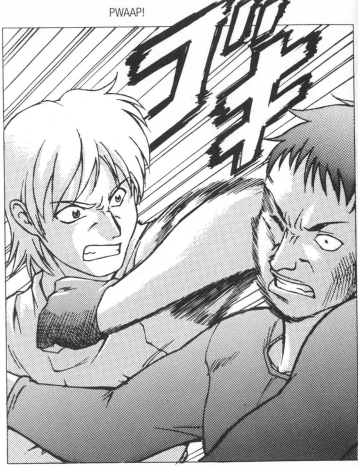

PWAAP!

Elbow punch

A dropped, twisted waist gives more power to the blow. Turning the wrist downwards, as illustrated, separate this move from standard elbow punches.

Use downward elbow punches together with the whole body. Picture images like dropping the waist from the elbow, crouching down from the elbow, etc., and draw them.

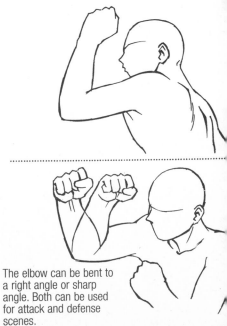

The elbow can be bent to a right angle or sharp angle. Both can be used for attack and defense scenes.

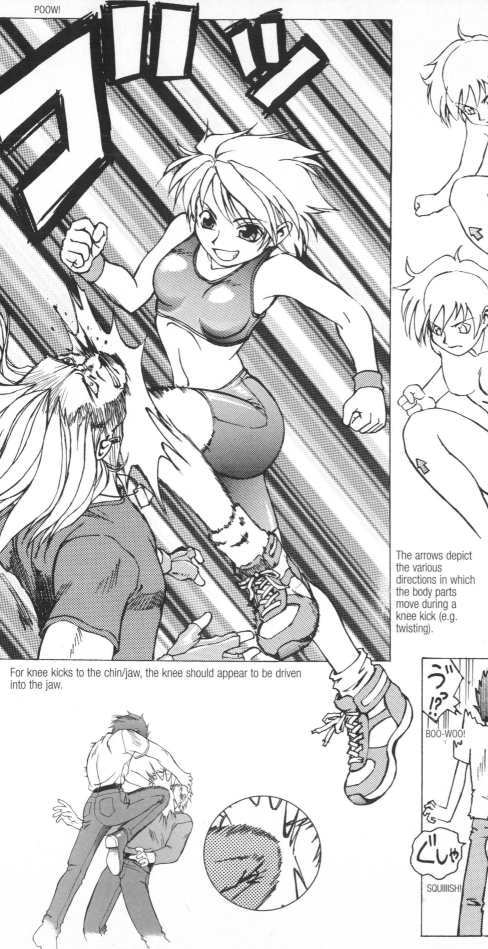

POOW!

The arrows depict the various directions in which the body parts move during a knee kick (e.g. twisting).

For knee kicks to the chin/jaw, the knee should appear to be driven into the jaw.

BOO-WOO!

SQUIIIISH!

# Dodging and Defending

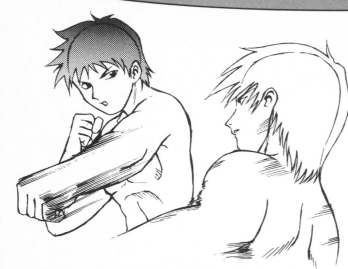

Dodging can be expressed by bending the neck and moving the body a little to the side.

The attack-character's line of sight stays fixed on the target even after he knows he has missed his target. By doing this you can suggest that this enemy is also a skilled fighter.

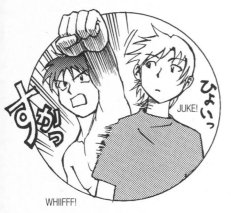

JUKE! ひょいっ

WHIIFFF!

An opponent left looking at the where the punch was thrown makes him look like an unskilled, amateur.

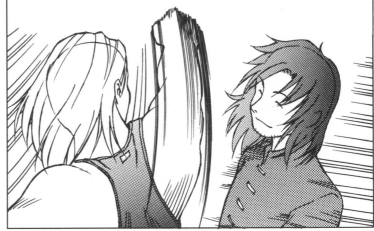

The more nonchalantly the dodge pose can be done, the cooler it looks. A slight flutter of the hair or the wrinkling of the clothing can express the visual direction of the movement.

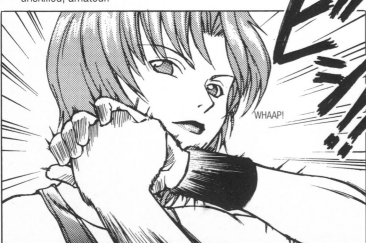

WHAAP!

There are two ways to block punches with your hands:
1) intercept the punch and 2) grab the punch
The key is to draw the punch aimed directly for the opponent's head without assuming anything about intercepting and grabbing the punch.

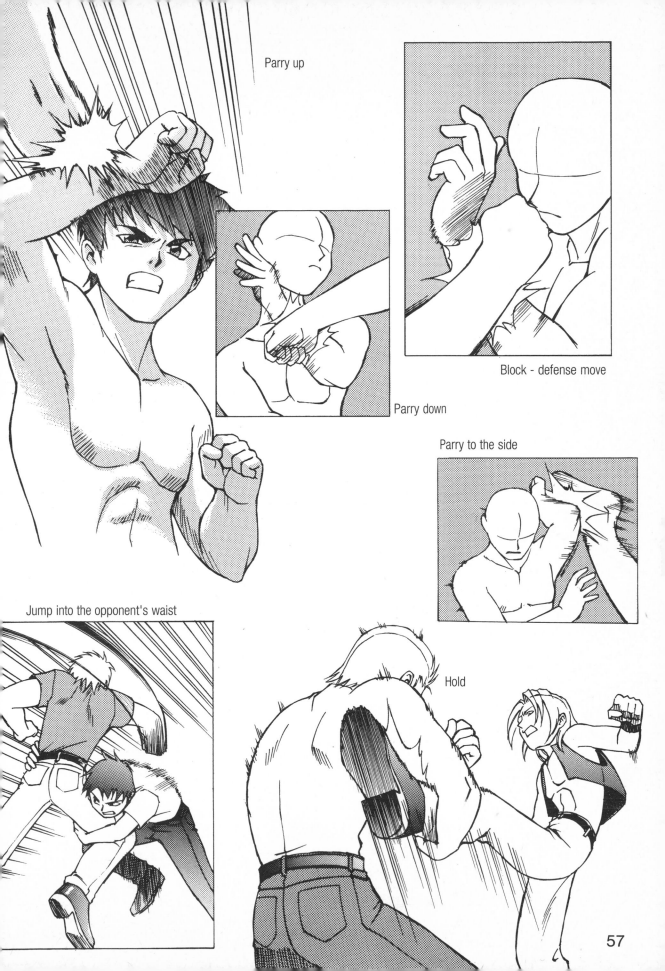

Parry up

Parry down

Block - defense move

Parry to the side

Jump into the opponent's waist

Hold

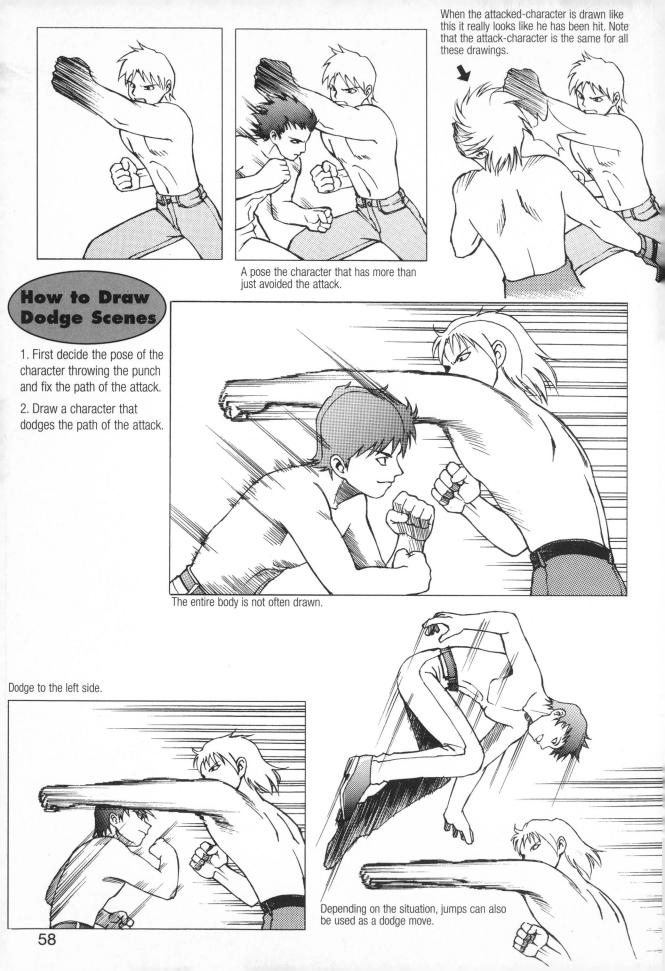

When the attacked-character is drawn like this it really looks like he has been hit. Note that the attack-character is the same for all these drawings.

A pose the character that has more than just avoided the attack.

## How to Draw Dodge Scenes

1. First decide the pose of the character throwing the punch and fix the path of the attack.

2. Draw a character that dodges the path of the attack.

The entire body is not often drawn.

Dodge to the left side.

Depending on the situation, jumps can also be used as a dodge move.

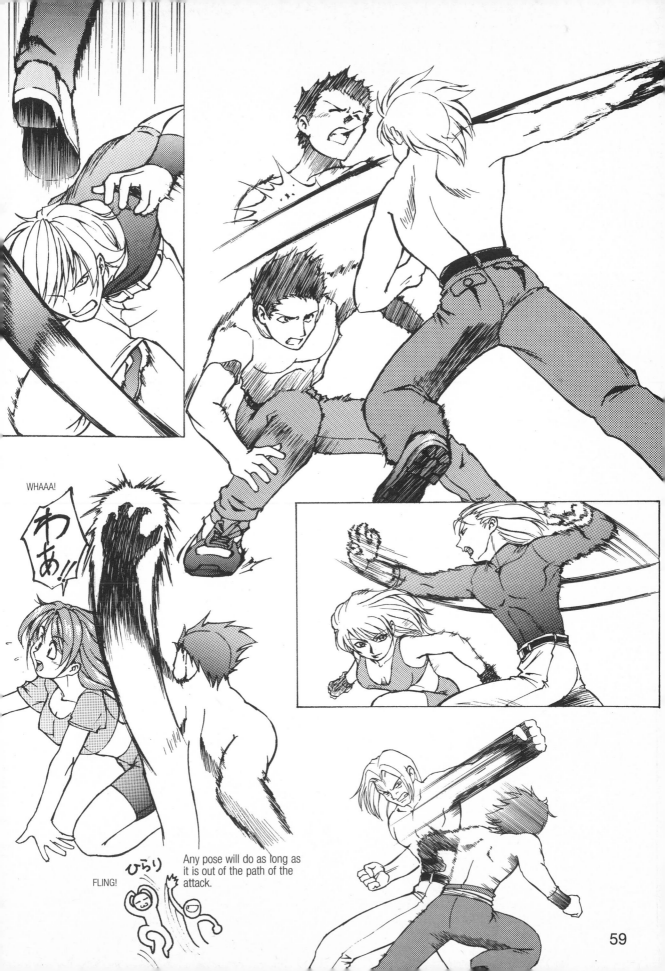

WHAAA!

わぁ!!

FLING!
ひらり

Any pose will do as long as it is out of the path of the attack.

# How to Draw Curved Effect Lines

## Using a Fine-Point Pen

Fine-point pens and draftsman's rulers are the general tools used. Ellipse templates and rib rulers are also often used.

1. Ellipse template and fine-point pen (about 0.3 mm)

2. Curved points like this are the curtain call for ellipse templates.

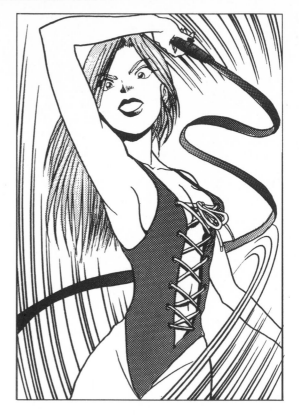

3. A long edged draftsman's ruler

4. A large spanned rib ruler

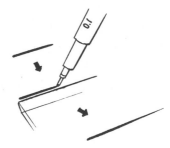

5. If the line is not sharp enough, go over it with a 0.1mm fine-point pen.

## Tools for Drawing Curved Lines

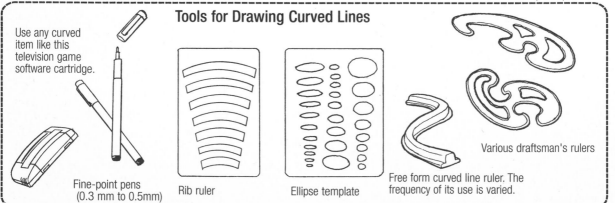

Use any curved item like this television game software cartridge.

Fine-point pens (0.3 mm to 0.5mm)

Rib ruler

Ellipse template

Various draftsman's rulers

Free form curved line ruler. The frequency of its use is varied.

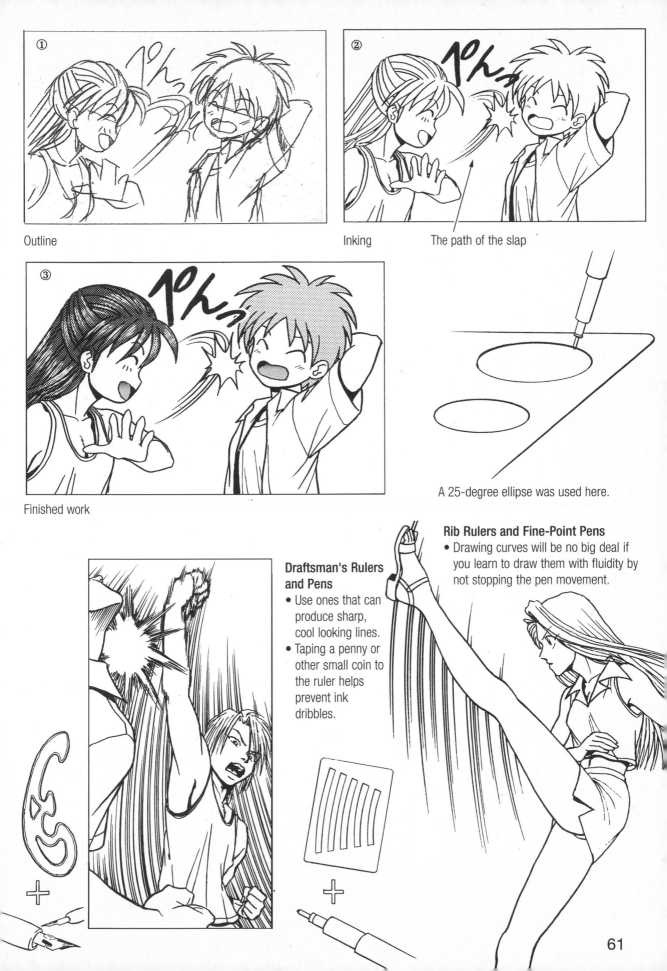

① Outline

② Inking

The path of the slap

③ Finished work

A 25-degree ellipse was used here.

**Draftsman's Rulers and Pens**
- Use ones that can produce sharp, cool looking lines.
- Taping a penny or other small coin to the ruler helps prevent ink dribbles.

**Rib Rulers and Fine-Point Pens**
- Drawing curves will be no big deal if you learn to draw them with fluidity by not stopping the pen movement.

# Expressing Weariness

Rounding the back really makes it look like he is worn out.

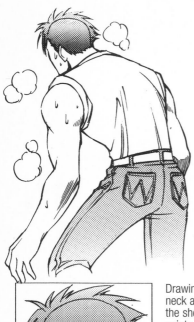

The pushed out chin, curved back and slightly forward body position makes the mind's eye see this character as out-of-breath and tired.

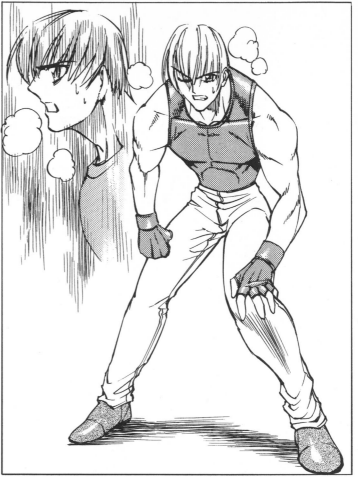

Drawing the neck a little on the short side points out the fact that the chin is forward and this expresses the weariness.

The direction of the ear shows that the character is looking at the opponent.

In doing so, this expresses that the character is tired but hasn't lost his fighting spirit.

Sweat, breath, frayed hair and dirt are all ways of expressing weariness.

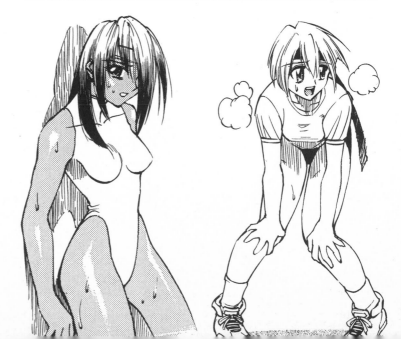

# CHAPTER 3

# DRAWING THROWS, GRABS AND GRAPPLING

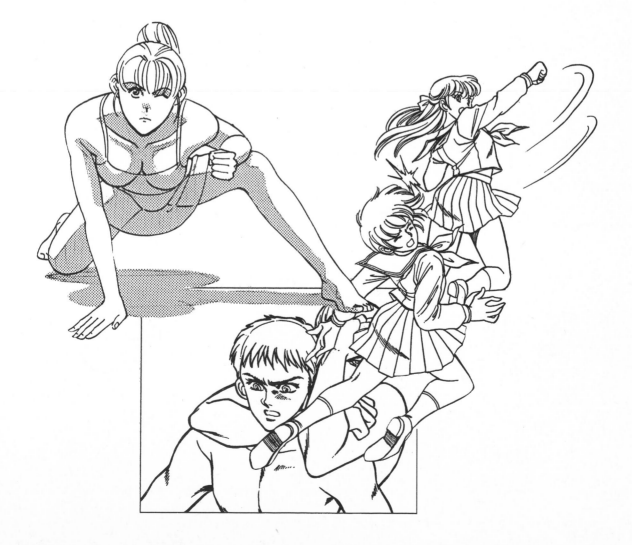

# Throwing

## 1. Grabbing the Arm and Throwing

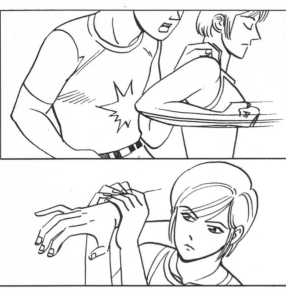

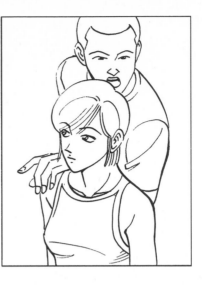

While rounding the back makes it really look like a throw, sometimes this is eliminated to make it look more mangaesque.

## 2. Making Throwing Scenes Simple

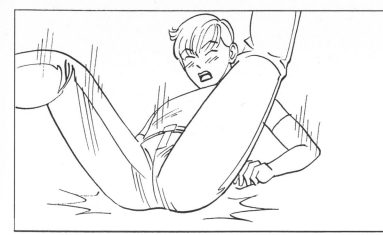

Combine poses where one character looks like he has thrown and the other looks like he has been thrown.

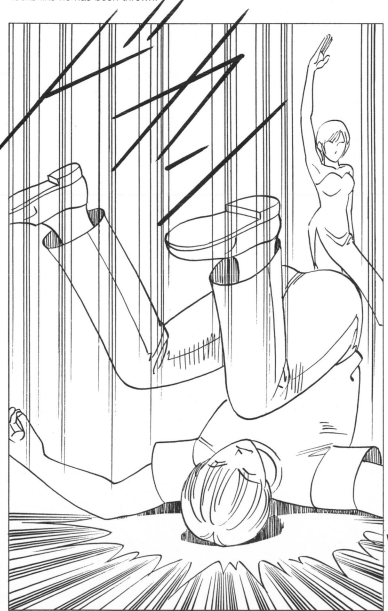

Draw poses where the character has been thrown with showiness.

'Given' cuts used before the result of the throw:

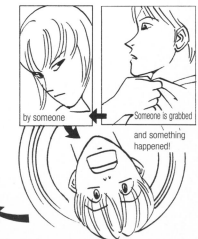

by someone

Someone is grabbed and something happened!

While a lot depends on the set-up, in manga, if you clearly express who has thrown who, for the most part you don't need to explain how the throw was actually done or what kind of throw was used.

## 3. Aikido Throws

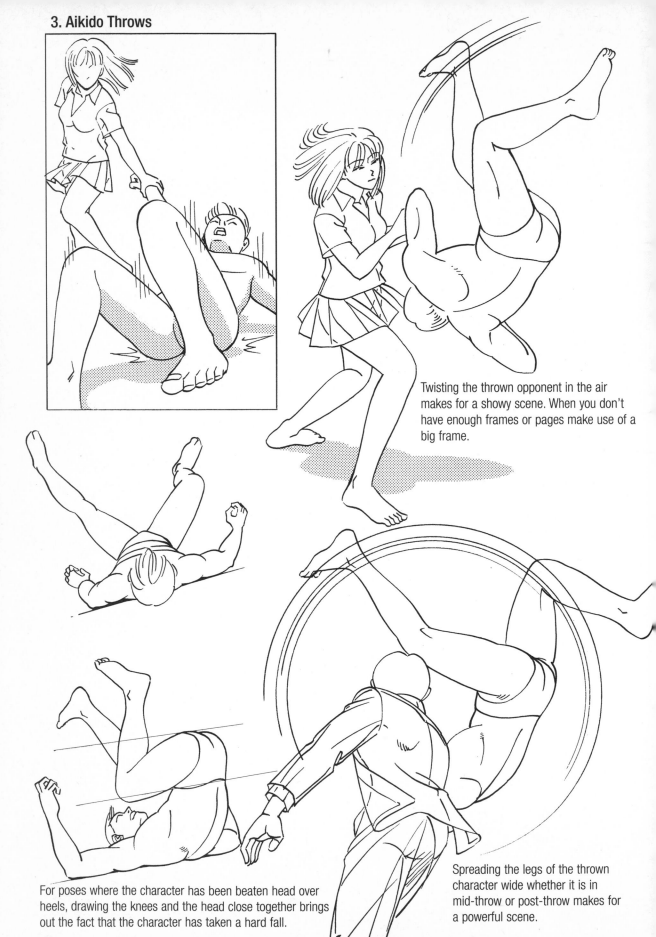

Twisting the thrown opponent in the air makes for a showy scene. When you don't have enough frames or pages make use of a big frame.

For poses where the character has been beaten head over heels, drawing the knees and the head close together brings out the fact that the character has taken a hard fall.

Spreading the legs of the thrown character wide whether it is in mid-throw or post-throw makes for a powerful scene.

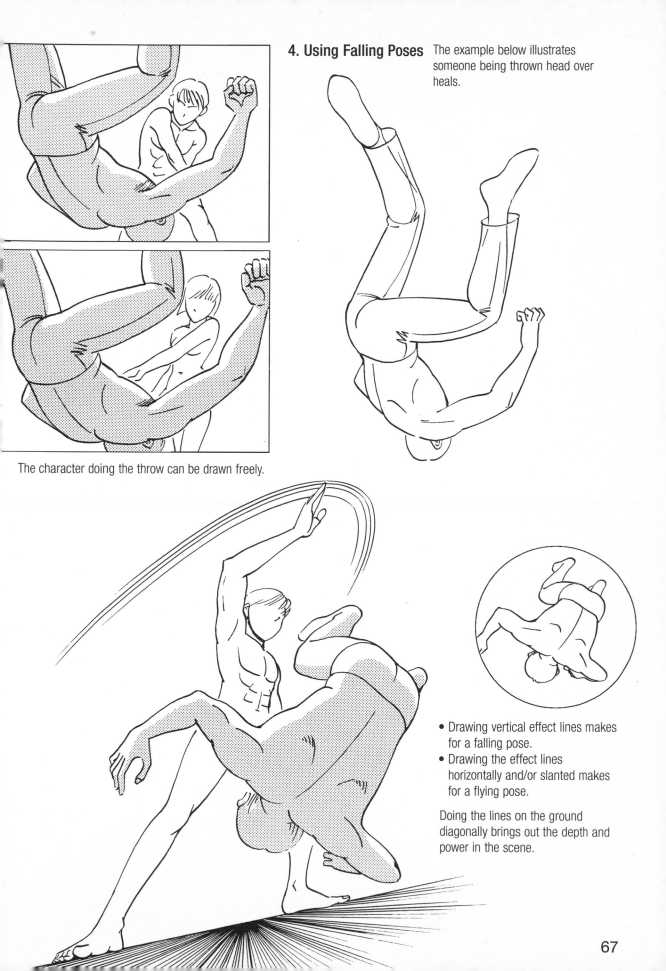

## 4. Using Falling Poses

The example below illustrates someone being thrown head over heals.

The character doing the throw can be drawn freely.

- Drawing vertical effect lines makes for a falling pose.
- Drawing the effect lines horizontally and/or slanted makes for a flying pose.

Doing the lines on the ground diagonally brings out the depth and power in the scene.

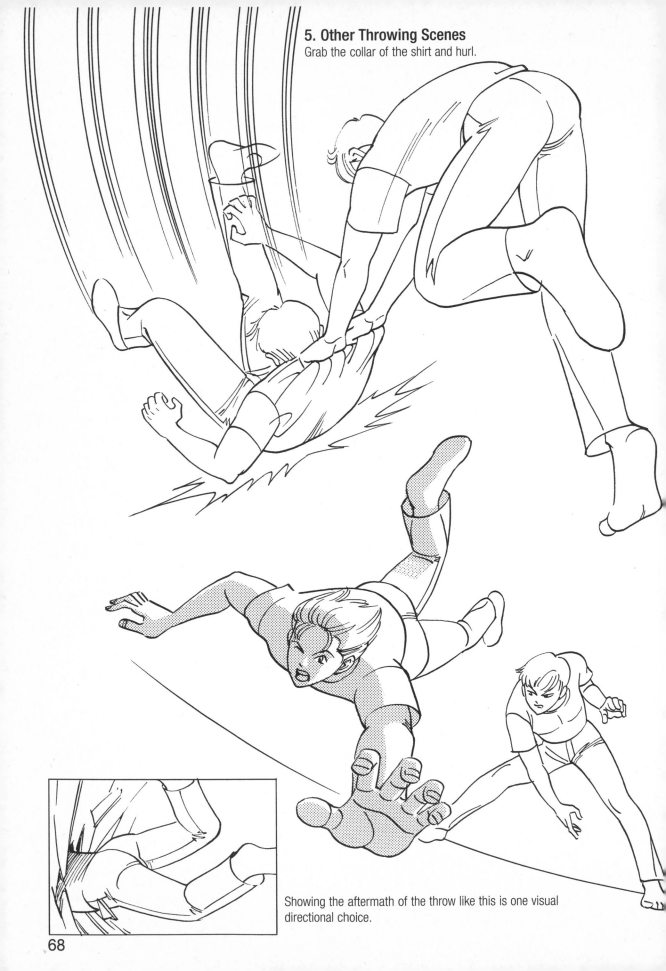

## 5. Other Throwing Scenes
Grab the collar of the shirt and hurl.

Showing the aftermath of the throw like this is one visual directional choice.

Showing a cut with the grab and another with the aftermath of the throw makes a throw scene materialize.

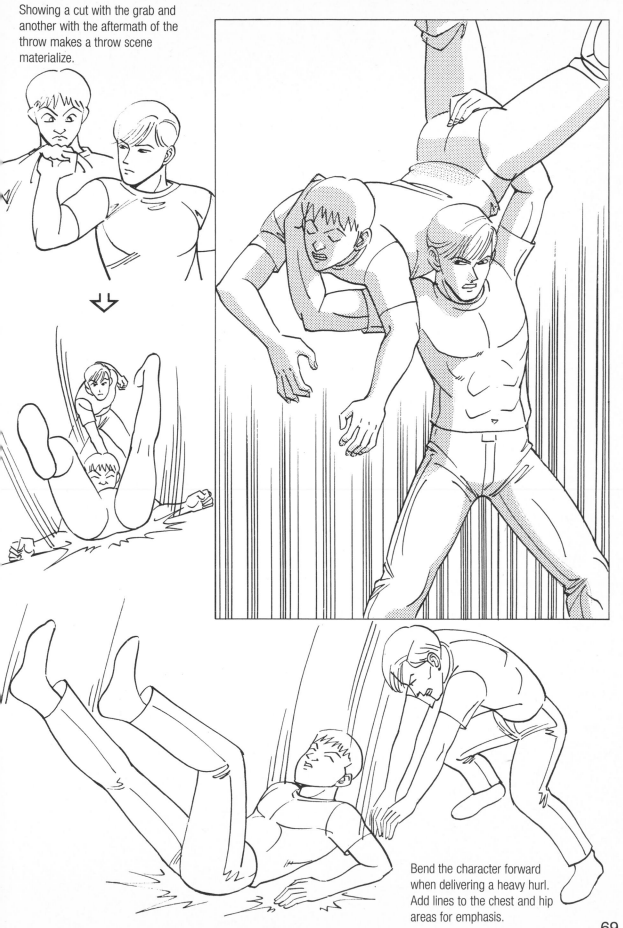

Bend the character forward when delivering a heavy hurl. Add lines to the chest and hip areas for emphasis.

# Having Your Doors Blown Off, Being Hurled Against Something

## 1. Male Examples

It will look showier if you spread the legs wide when the character has his doors blown off.

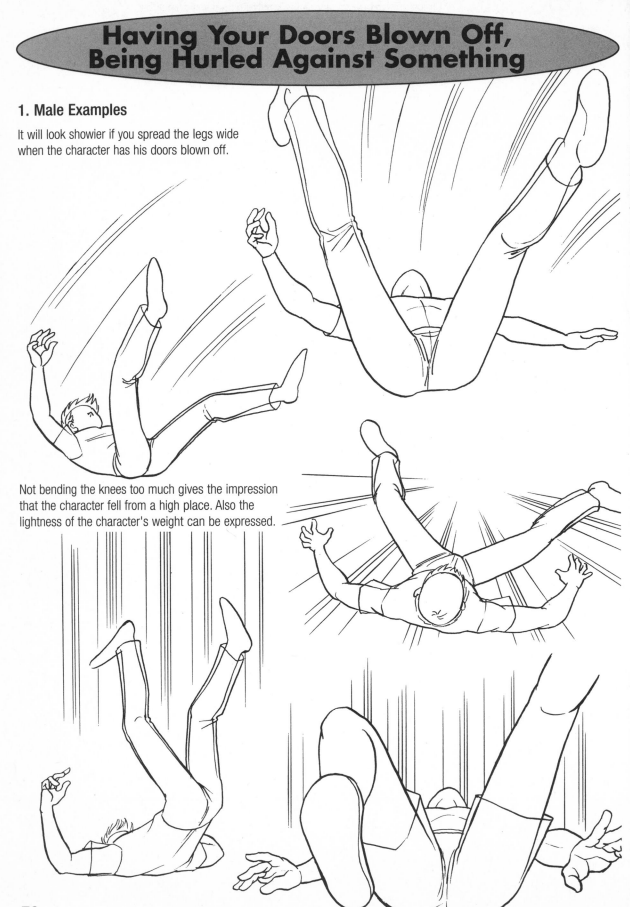

Not bending the knees too much gives the impression that the character fell from a high place. Also the lightness of the character's weight can be expressed.

Bending the waist and knees can help express from which direction the character was flung and/or how the character was hurled against something.

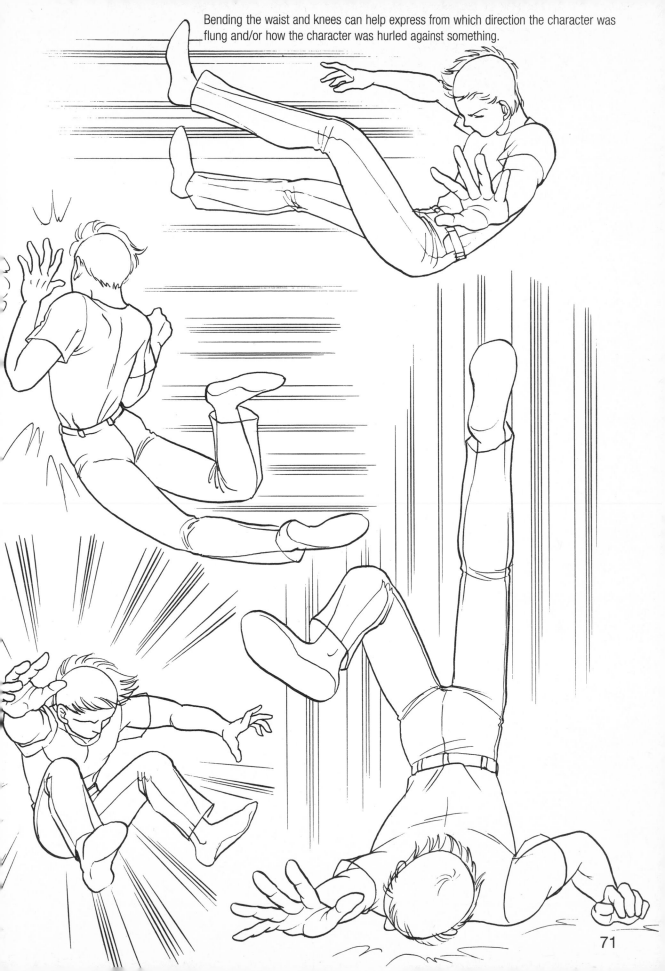

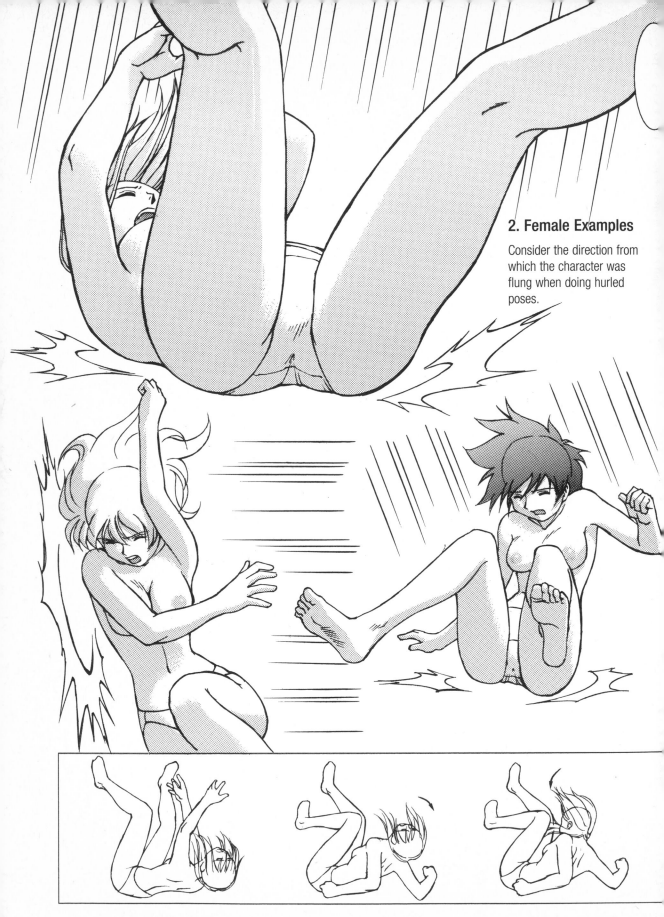

## 2. Female Examples

Consider the direction from which the character was flung when doing hurled poses.

Usually at times when the character has been flung, the body has lost its energy so the legs also bend.

Tilting the head back gives the sensation that the character has been defeated.

Raising the head makes the character look like she is enduring the event.

Express the direction from which the character was flung with the hair. After being flung, the hair flutters in the opposite direction from where the character flew in the air.

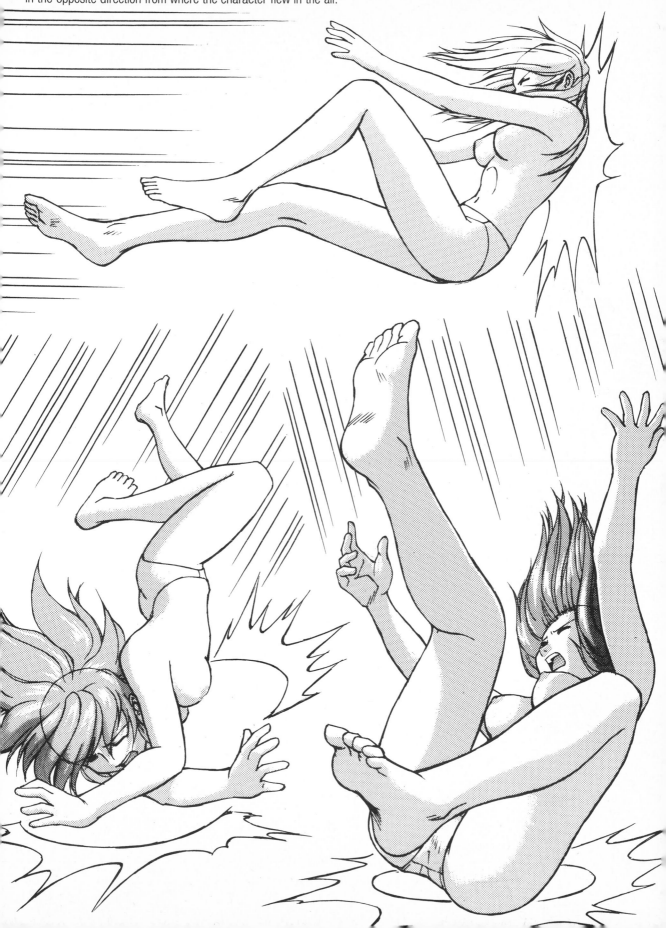

# Grabbing

## 1. Grabbing Shirt Collars

The wrinkles in the clothes centrally gather around the area that has been grabbed.

Since the clothing gets wrapped around in the hand during a grab, wrinkles form along the fingers and joints.

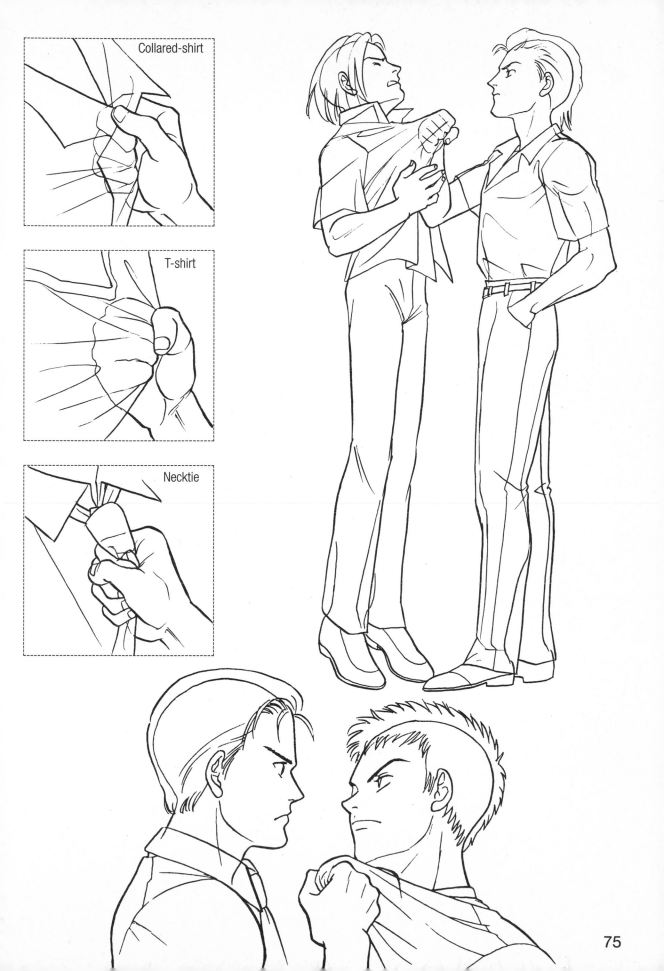

Collared-shirt

T-shirt

Necktie

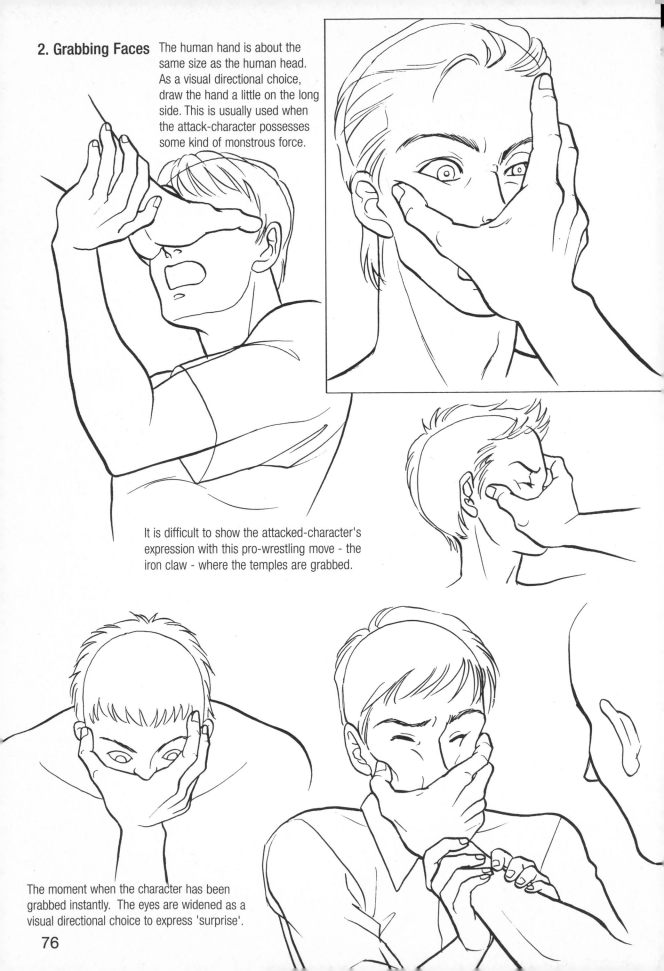

## 2. Grabbing Faces

The human hand is about the same size as the human head. As a visual directional choice, draw the hand a little on the long side. This is usually used when the attack-character possesses some kind of monstrous force.

It is difficult to show the attacked-character's expression with this pro-wrestling move - the iron claw - where the temples are grabbed.

The moment when the character has been grabbed instantly. The eyes are widened as a visual directional choice to express 'surprise'.

### 3. Grabbing Throats

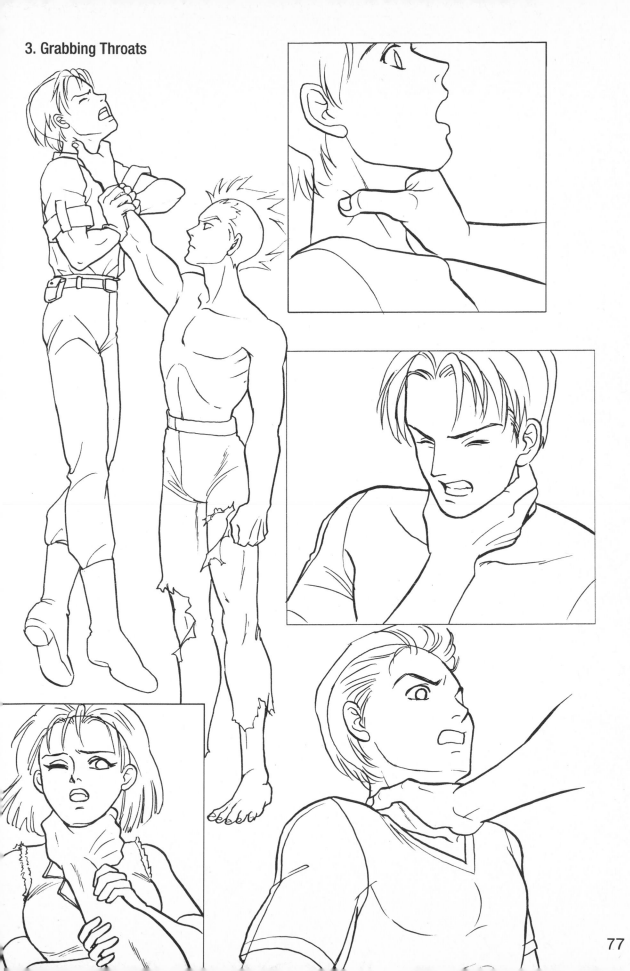

## 4. Grabbing Arms

As a visual directional choice, the movement of the hand grabbing the arm can then be used to prevent the opponent from moving (i.e. turning a grappling move into a locking move).

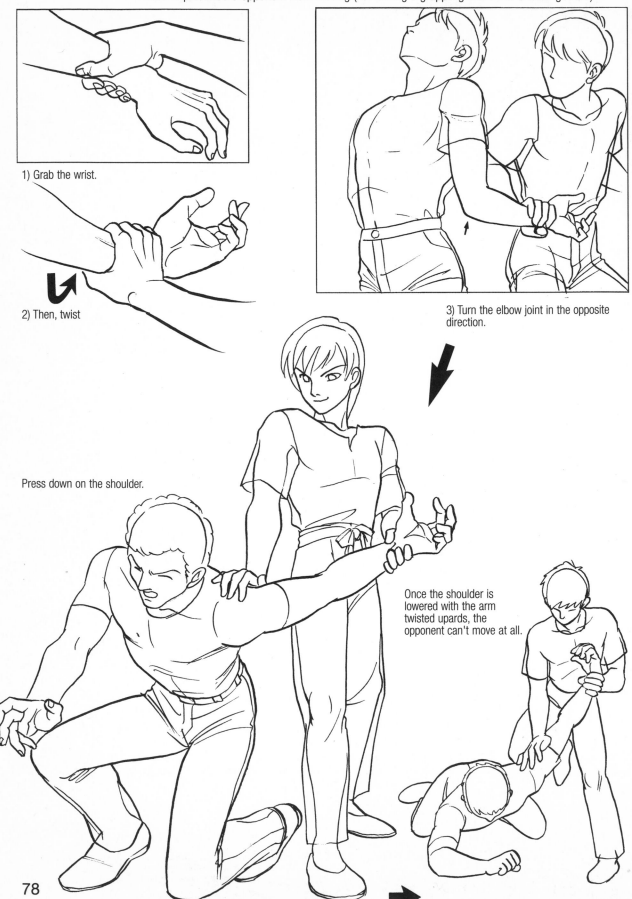

1) Grab the wrist.

2) Then, twist

3) Turn the elbow joint in the opposite direction.

Press down on the shoulder.

Once the shoulder is lowered with the arm twisted upards, the opponent can't move at all.

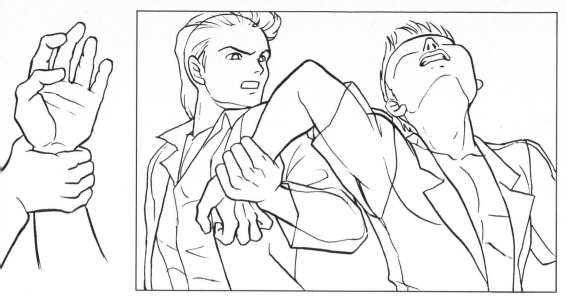

Grab the opponent's wrist like this. Twisting requires technique. (This becomes a job for a real pro).

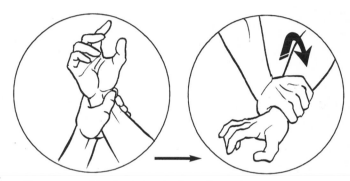

There are a variety of ways to twist depending on the way the opponent is grabbed.

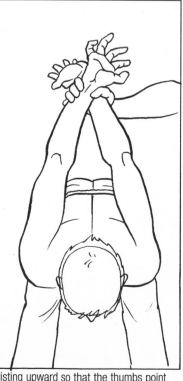

Twisting upward so that the thumbs point
outward makes the upper-body fall forward.

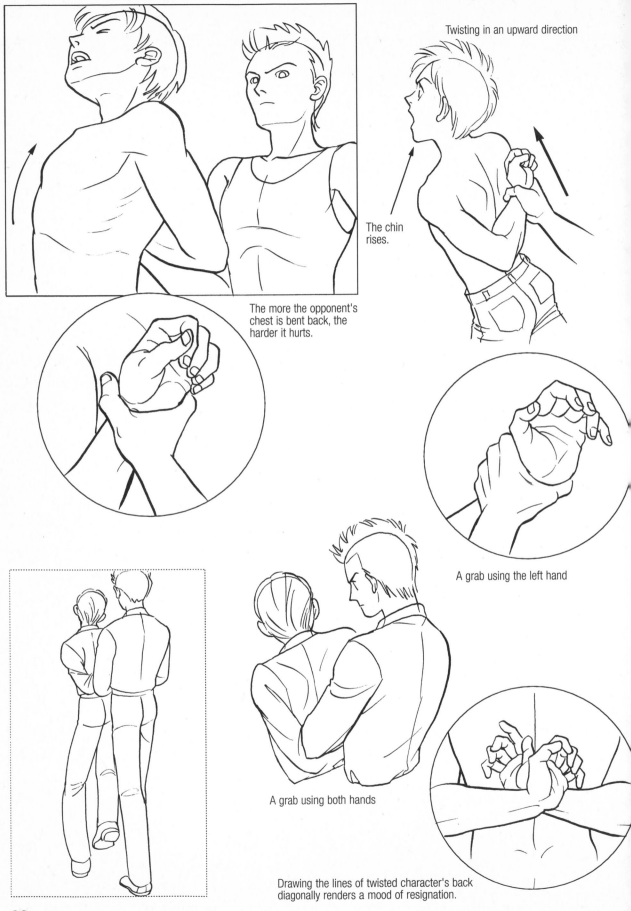

Twisting in an upward direction

The chin rises.

The more the opponent's chest is bent back, the harder it hurts.

A grab using the left hand

A grab using both hands

Drawing the lines of twisted character's back diagonally renders a mood of resignation.

# Detaining

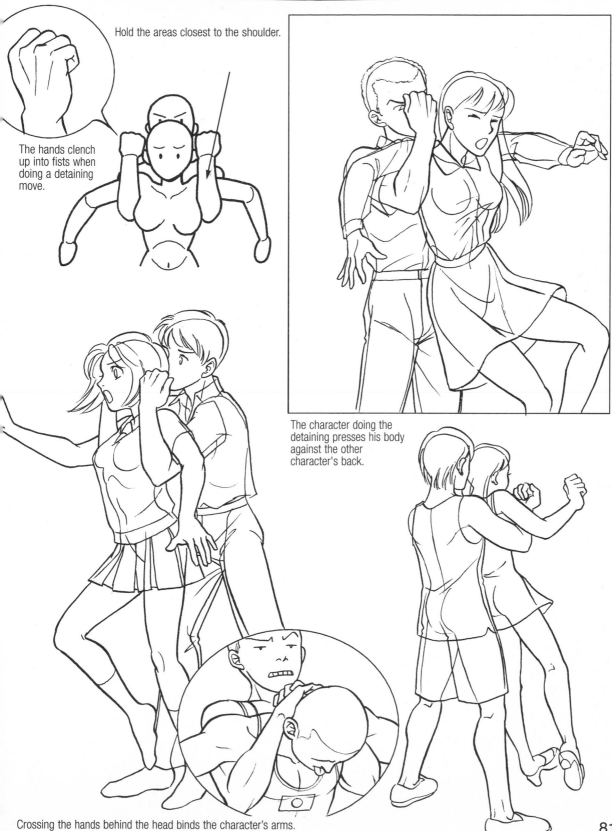

Hold the areas closest to the shoulder.

The hands clench up into fists when doing a detaining move.

The character doing the detaining presses his body against the other character's back.

Crossing the hands behind the head binds the character's arms.

Since the character being detaining is trying to move forward, the body leans forward.

The arms' range of movement

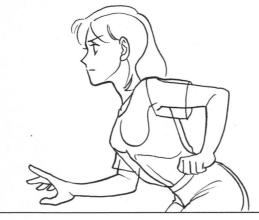

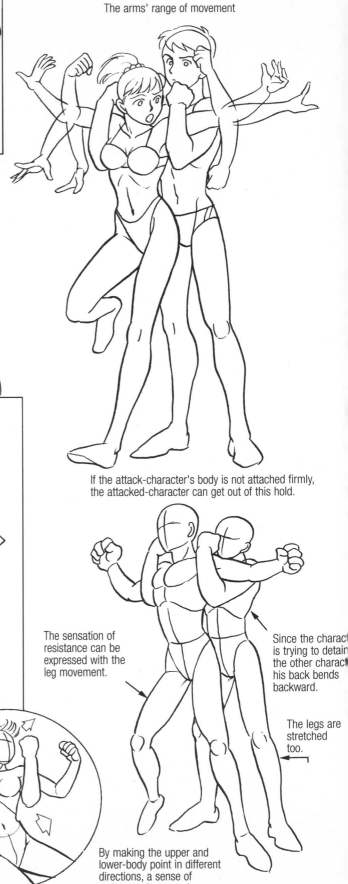

If the attack-character's body is not attached firmly, the attacked-character can get out of this hold.

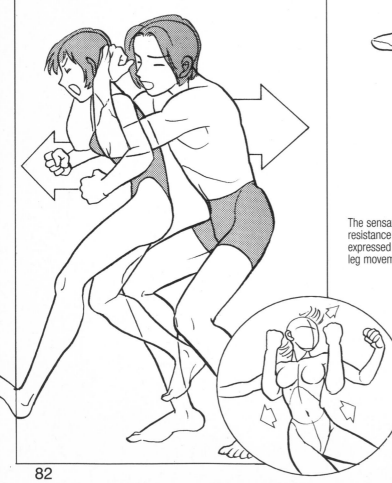

The sensation of resistance can be expressed with the leg movement.

Since the charac[t] is trying to detai[n] the other charac[t] his back bends backward.

The legs are stretched too.

By making the upper and lower-body point in different directions, a sense of resistance is created.

## 1. Escape Techniques

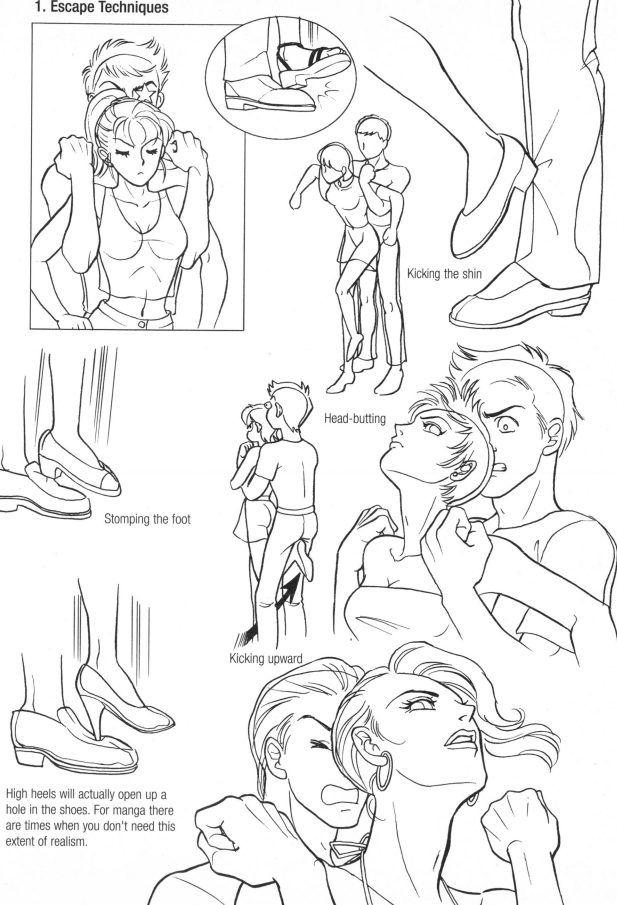

Kicking the shin

Stomping the foot

Head-butting

Kicking upward

High heels will actually open up a hole in the shoes. For manga there are times when you don't need this extent of realism.

## 2. Grabbing from Behind

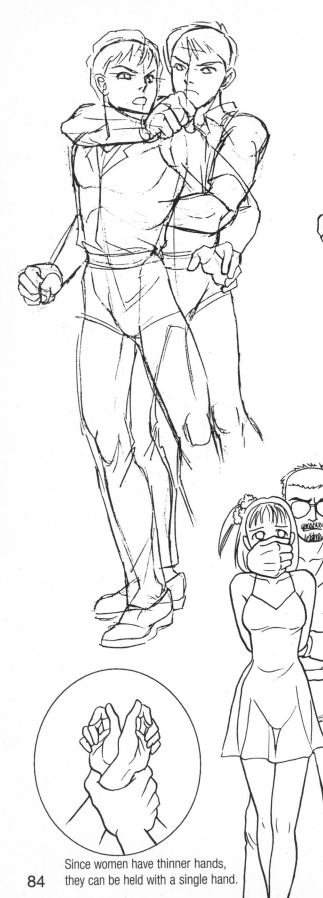

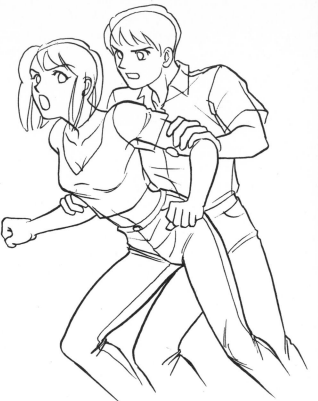

The key areas involved are the arm, armpit, and the neck.

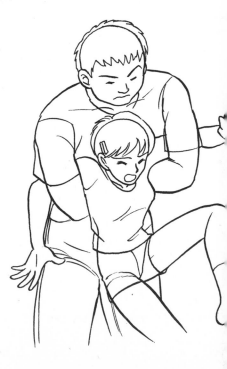

Since women have thinner hands, they can be held with a single hand.

An example illustrating a significant difference in body size.

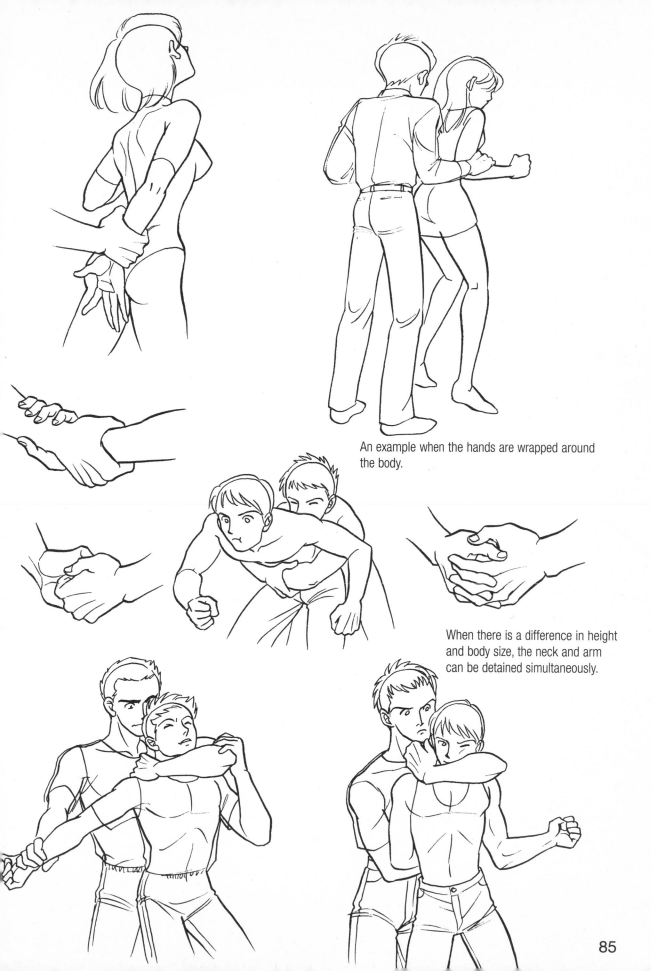

An example when the hands are wrapped around the body.

When there is a difference in height and body size, the neck and arm can be detained simultaneously.

# Lunging

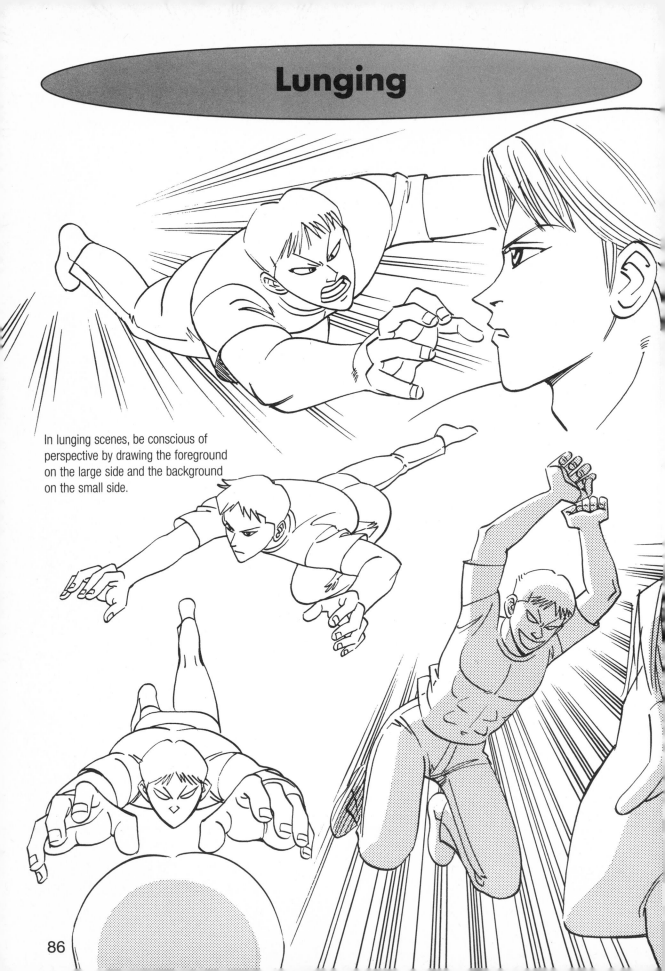

In lunging scenes, be conscious of perspective by drawing the foreground on the large side and the background on the small side.

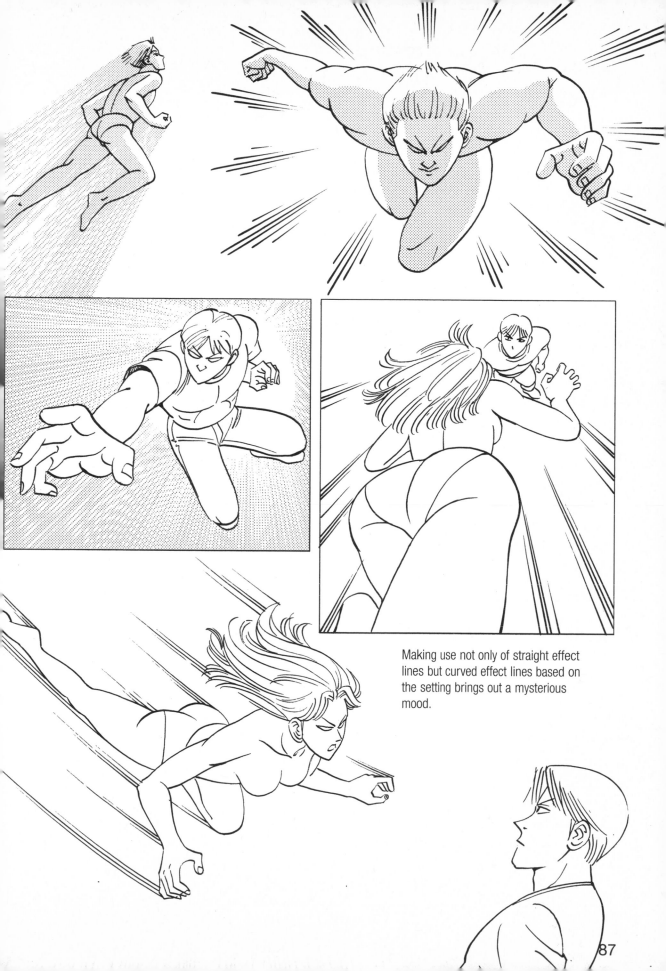

Making use not only of straight effect lines but curved effect lines based on the setting brings out a mysterious mood.

# Punching Sitting Astride

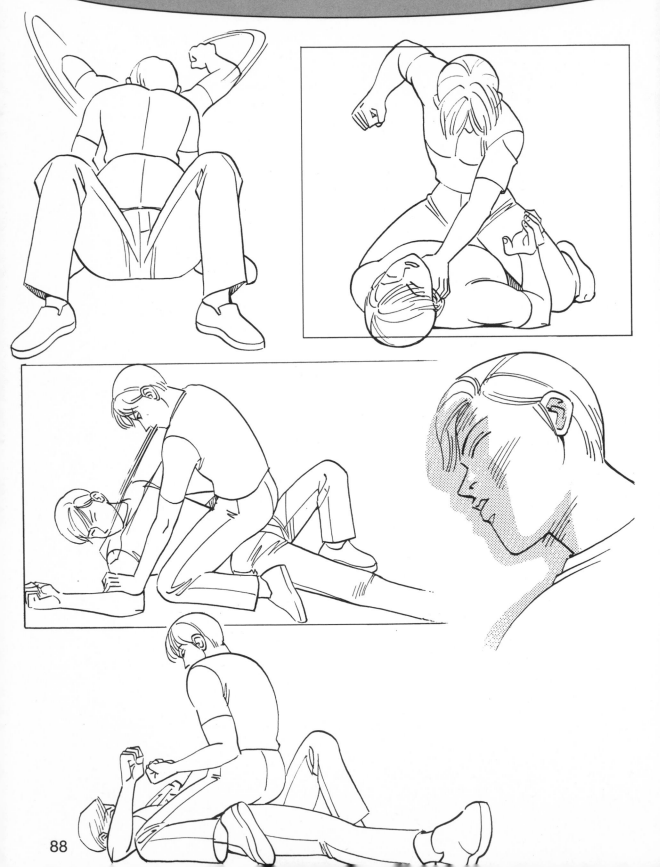

When grabbing the hair, keep
the skull in mind.

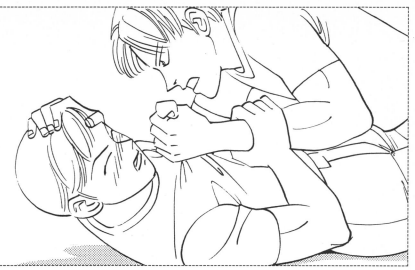

Adding a shadow makes it easy to understand that the character is trying to
raise his head.

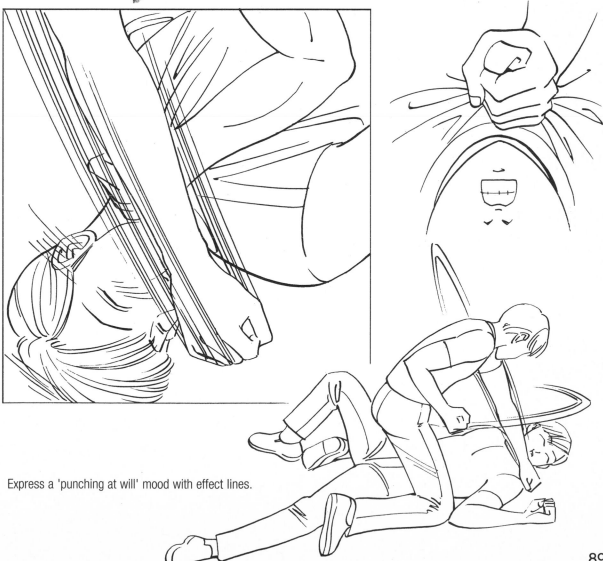

Express a 'punching at will' mood with effect lines.

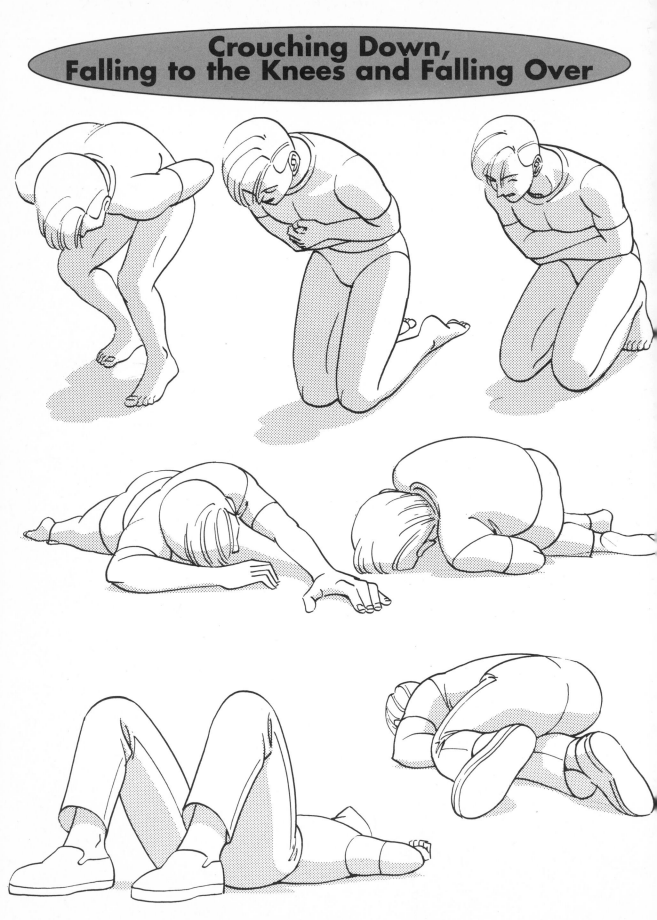

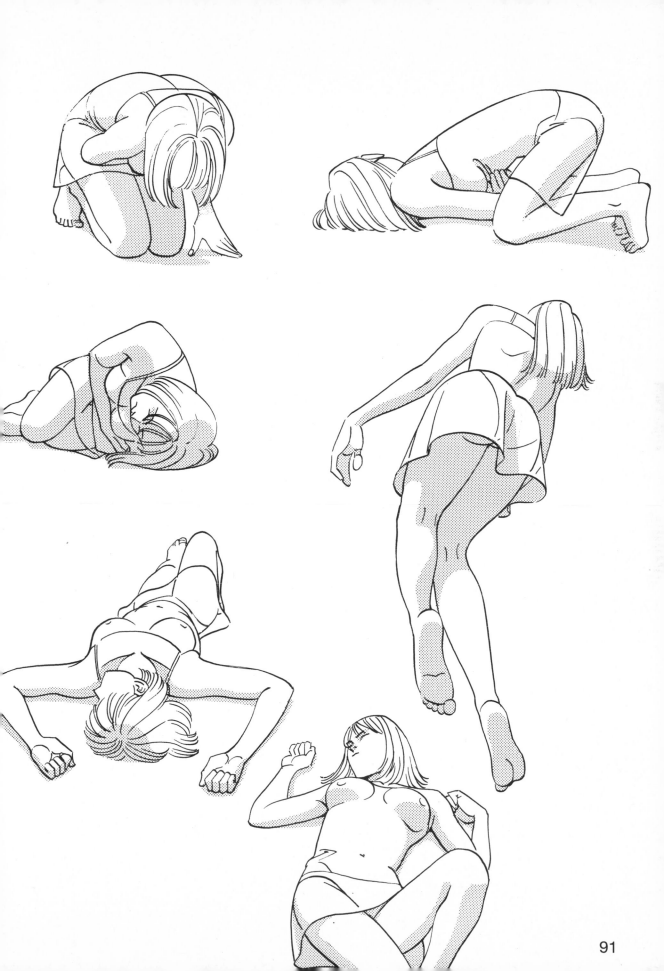

# Getting Up and Standing Up

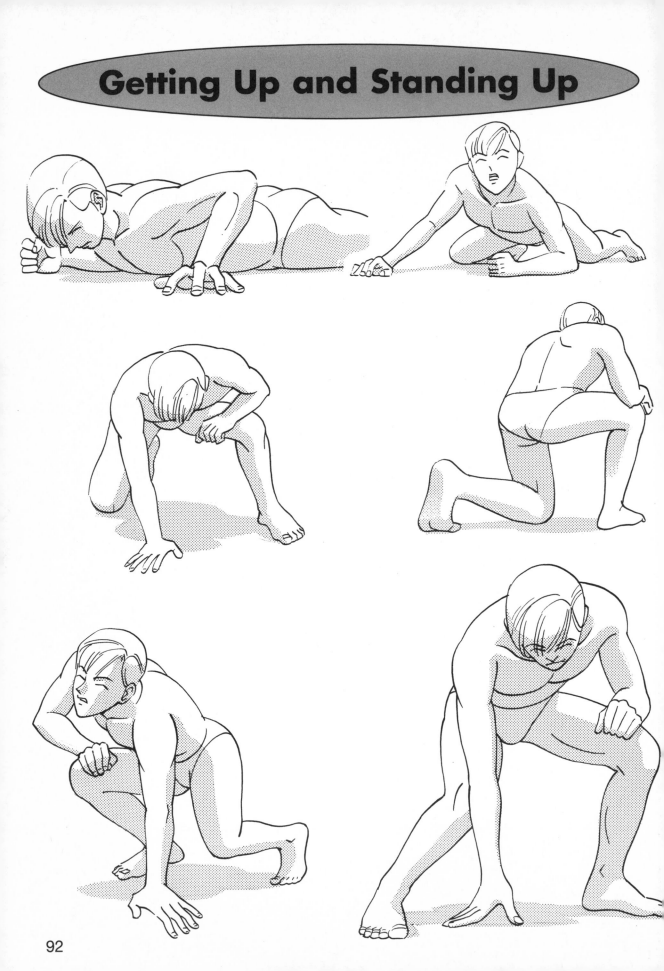

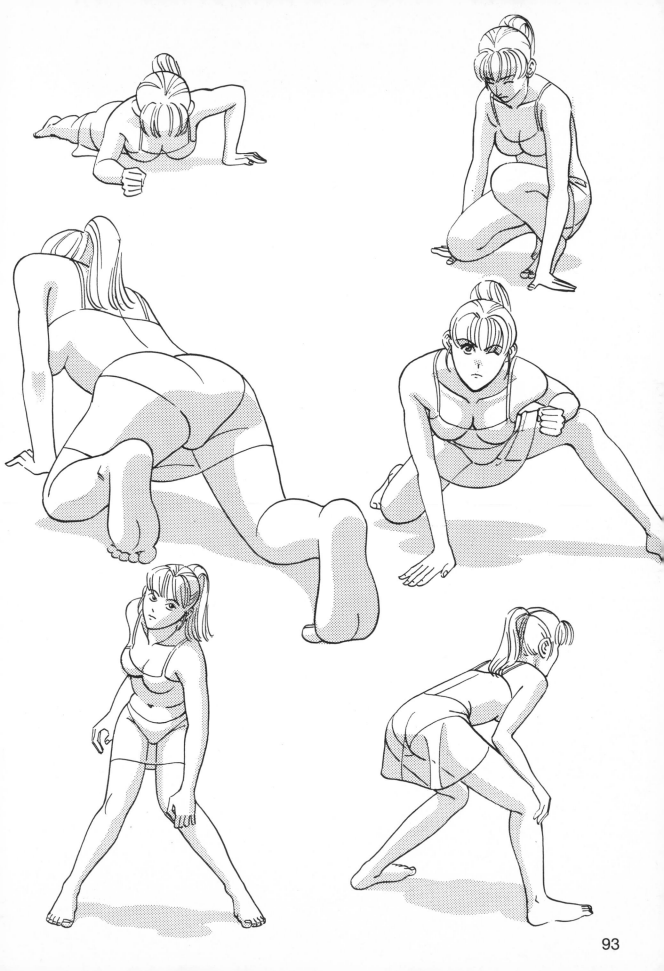

# Head-locks and Sleeper Holds

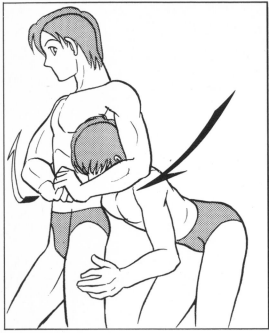

## 1. Basic Head-lock Patterns

Holding down the opponent's head in a headlock is one, very popular pro-wrestling move.

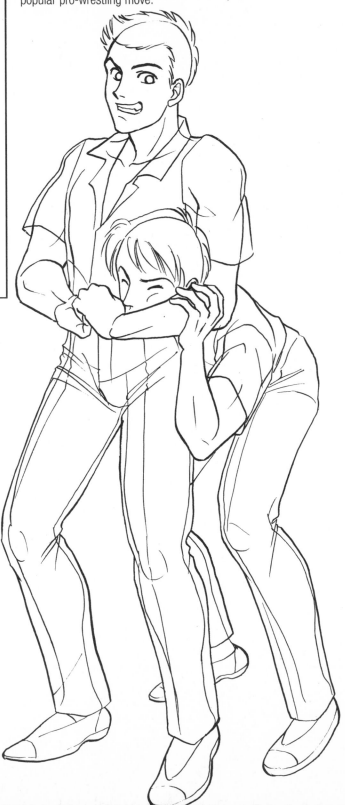

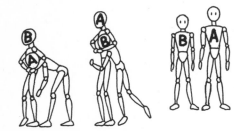

Differences in height affect the degrees to which the body bends forward.

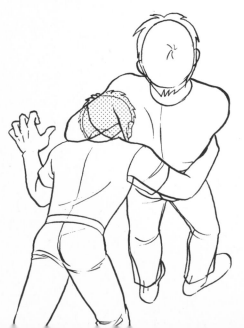

## 2. Lock Variations

Locking the head showing the face

Locking the neck

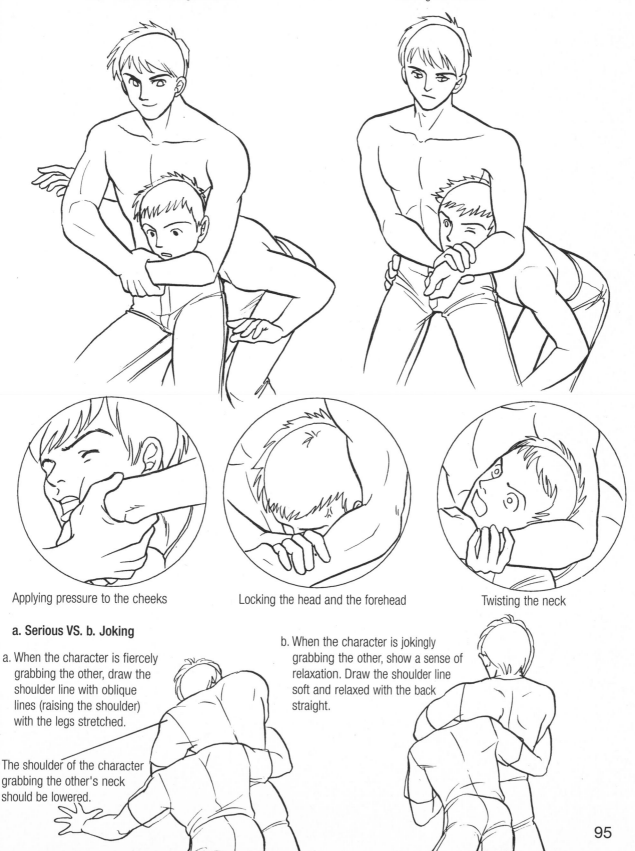

Applying pressure to the cheeks

Locking the head and the forehead

Twisting the neck

### a. Serious VS. b. Joking

a. When the character is fiercely grabbing the other, draw the shoulder line with oblique lines (raising the shoulder) with the legs stretched.

The shoulder of the character grabbing the other's neck should be lowered.

b. When the character is jokingly grabbing the other, show a sense of relaxation. Draw the shoulder line soft and relaxed with the back straight.

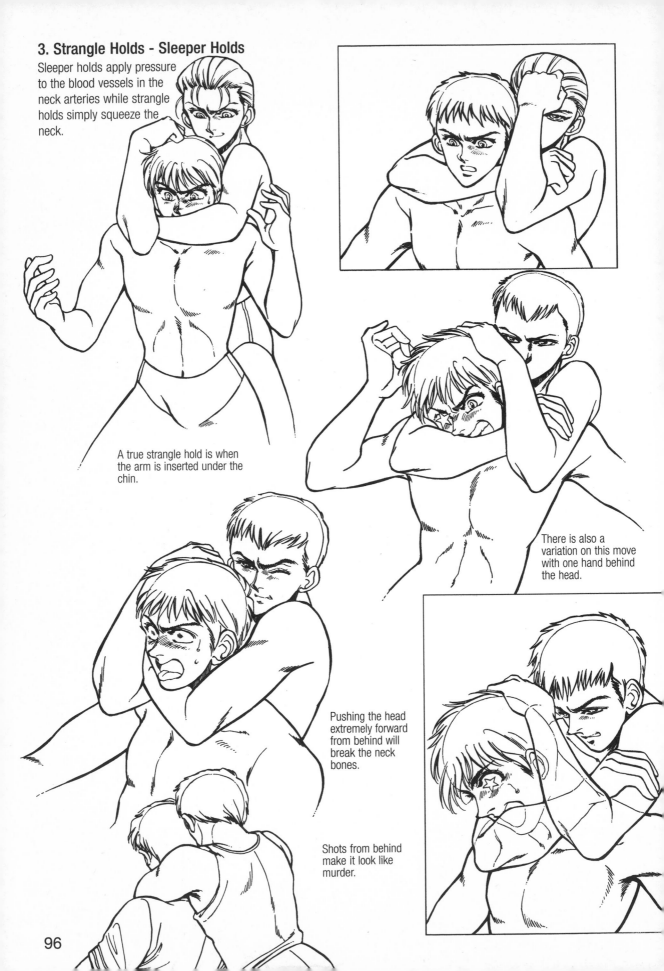

### 3. Strangle Holds - Sleeper Holds

Sleeper holds apply pressure to the blood vessels in the neck arteries while strangle holds simply squeeze the neck.

A true strangle hold is when the arm is inserted under the chin.

There is also a variation on this move with one hand behind the head.

Pushing the head extremely forward from behind will break the neck bones.

Shots from behind make it look like murder.

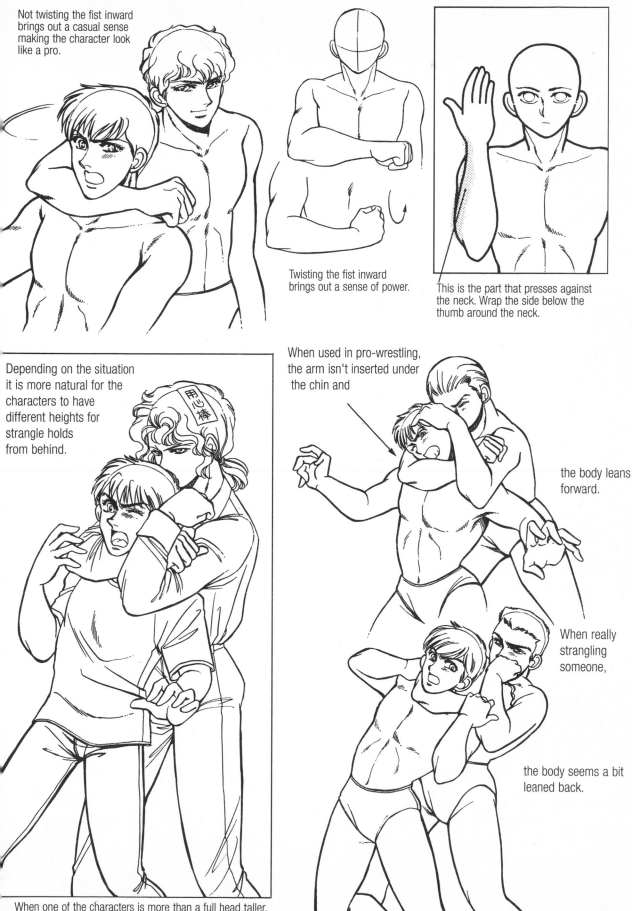

Not twisting the fist inward brings out a casual sense making the character look like a pro.

Twisting the fist inward brings out a sense of power.

This is the part that presses against the neck. Wrap the side below the thumb around the neck.

Depending on the situation it is more natural for the characters to have different heights for strangle holds from behind.

When used in pro-wrestling, the arm isn't inserted under the chin and

the body leans forward.

When really strangling someone,

the body seems a bit leaned back.

When one of the characters is more than a full head taller, the length and width of the legs are also different.

# Sailor Suit School Uniform Battles

The most suitable way to comprehend these battle scenes is to study the various movements of the skirt.

**1. Punching**

A sense of lively motion is rendered by adding movement to the hair along with the movement of the skirt.

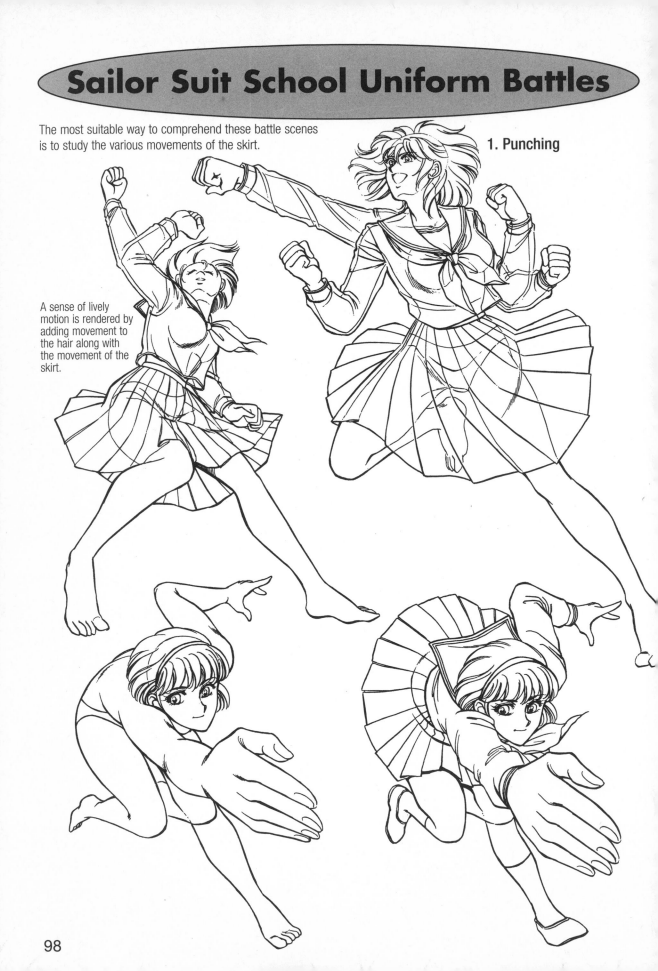

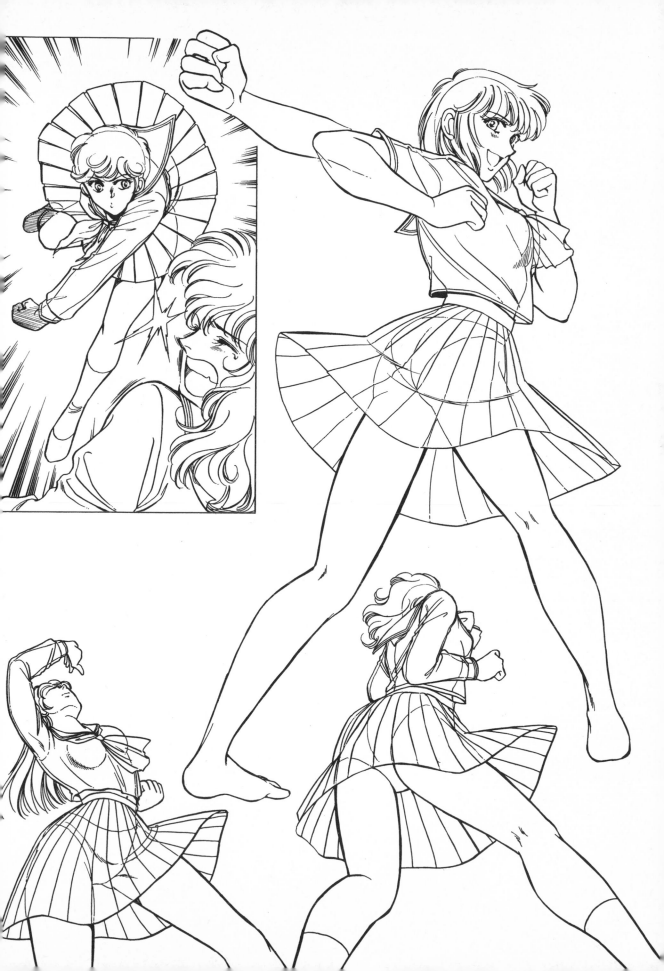

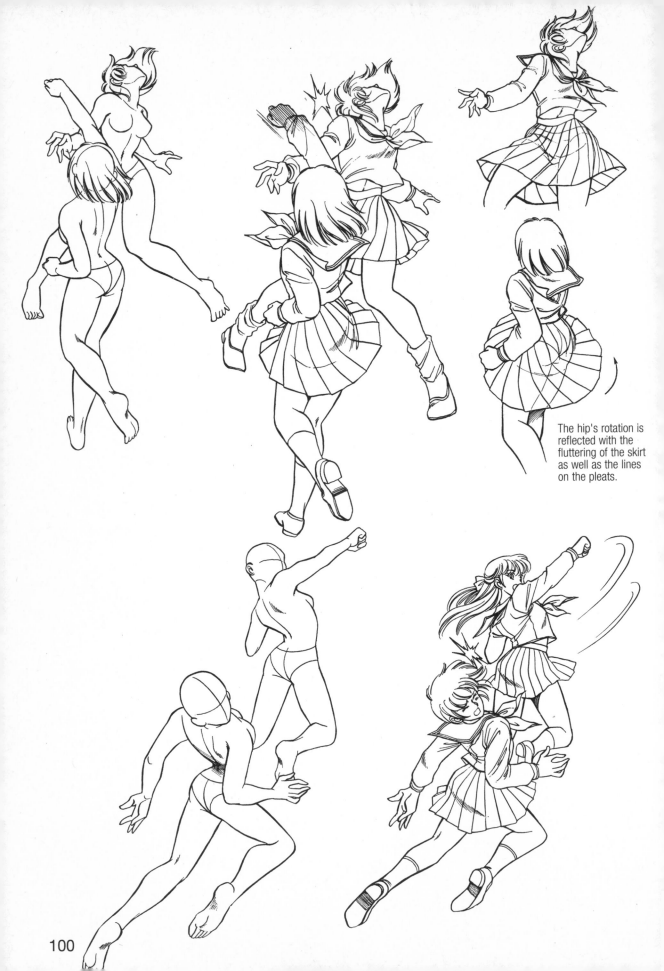

The hip's rotation is reflected with the fluttering of the skirt as well as the lines on the pleats.

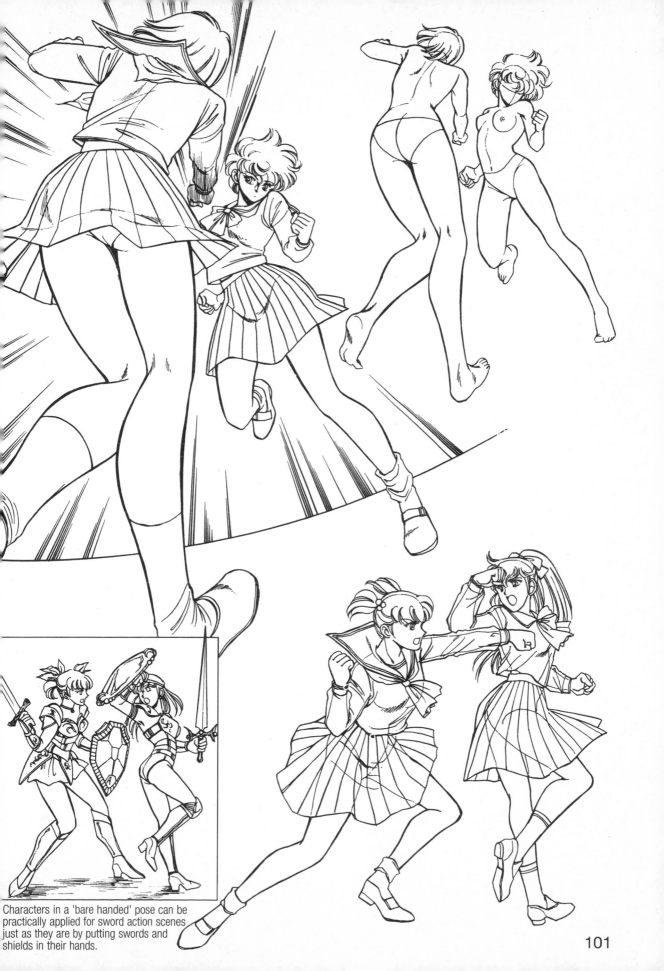

Characters in a 'bare handed' pose can be practically applied for sword action scenes just as they are by putting swords and shields in their hands.

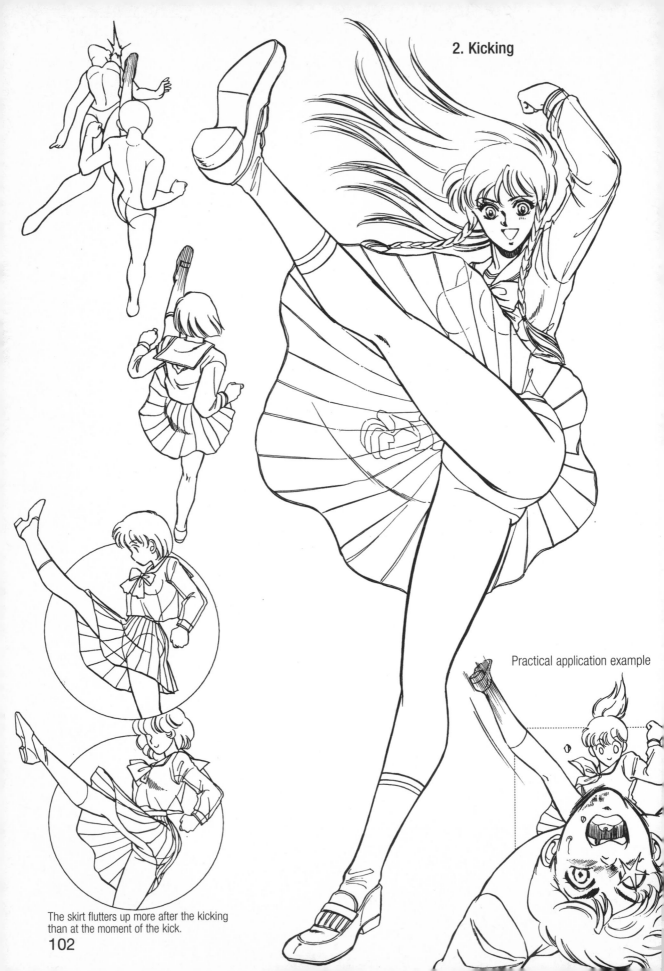

## 2. Kicking

Practical application example

The skirt flutters up more after the kicking than at the moment of the kick.

By changing the effect lines and lines of the leg, a front kick can become a sidekick.

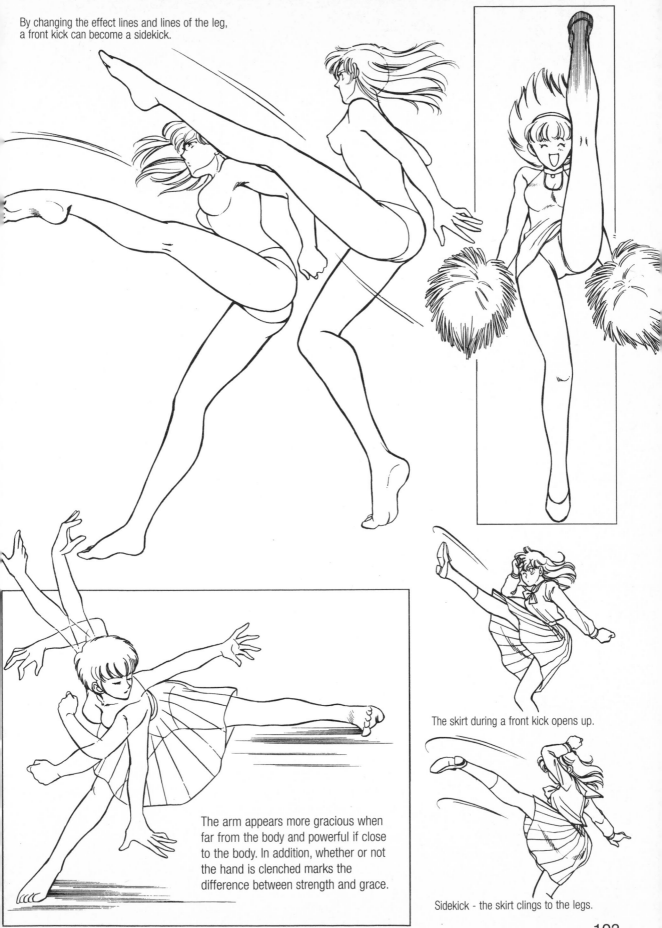

The skirt during a front kick opens up.

The arm appears more gracious when far from the body and powerful if close to the body. In addition, whether or not the hand is clenched marks the difference between strength and grace.

Sidekick - the skirt clings to the legs.

103

Even if the body parts are the same, the nature of the techniques and atmosphere can be changed by:

• direction of the axis of the leg and the kicking leg
• direction of the arm and the face
• the type of fluttering in the hair, etc.

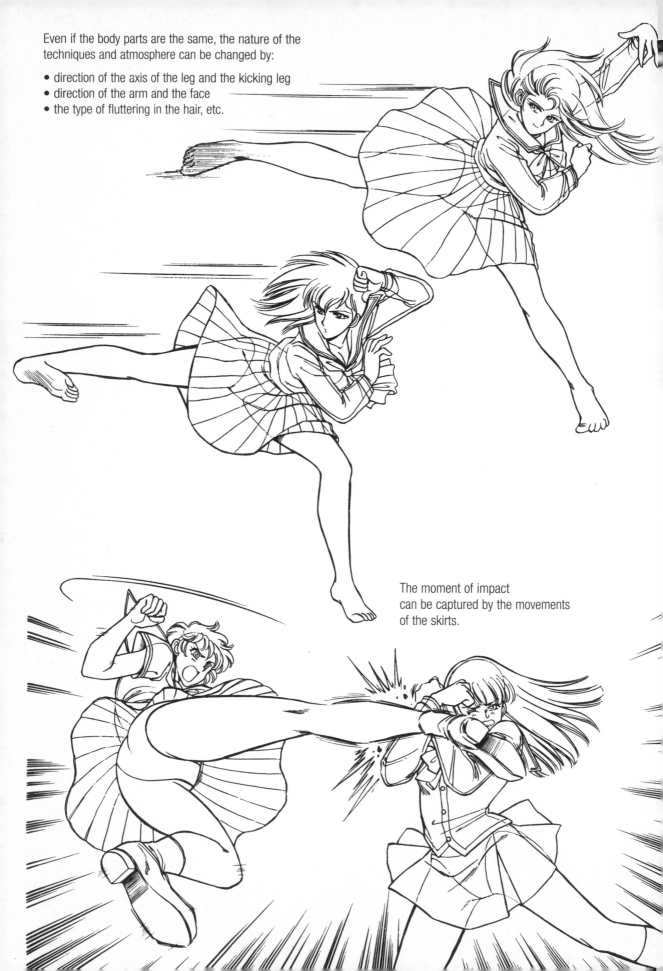

The moment of impact
can be captured by the movements
of the skirts.

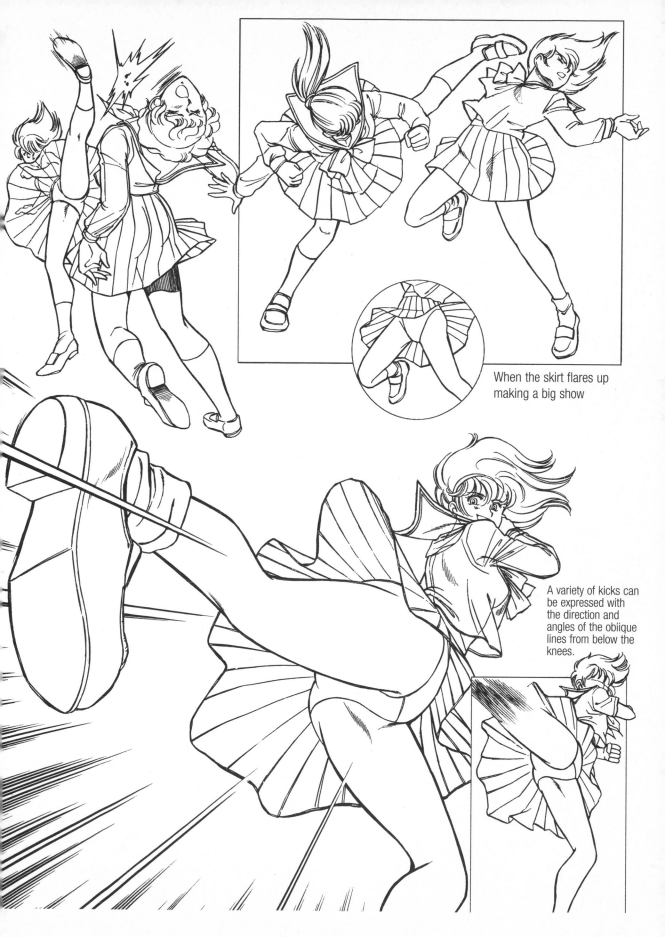

When the skirt flares up
making a big show

A variety of kicks can
be expressed with
the direction and
angles of the oblique
lines from below the
knees.

## 3. Throwing

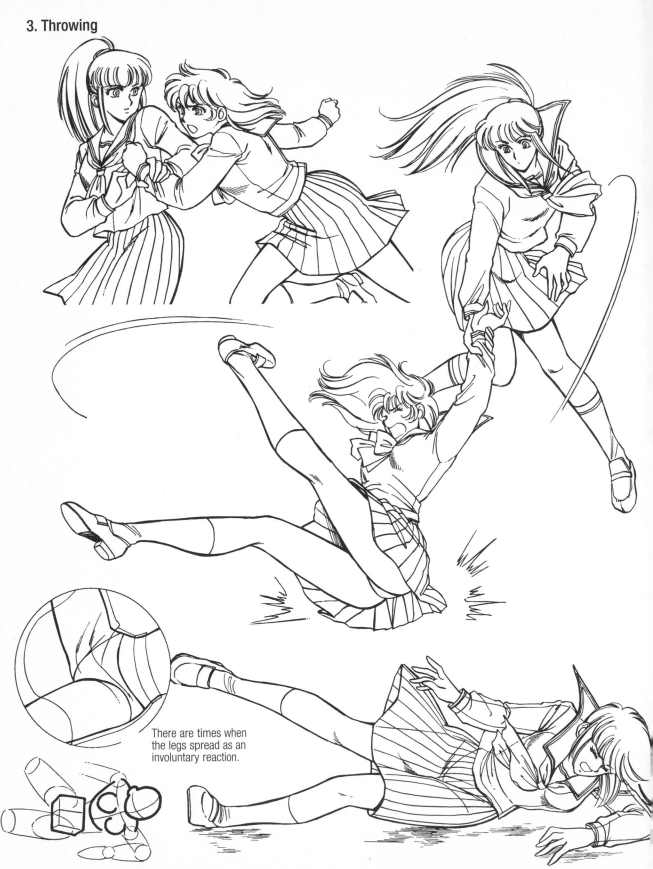

There are times when the legs spread as an involuntary reaction.

Changing the direction of the upper and lower-body shows the movement.

# 4. Pro-Wrestling Techniques

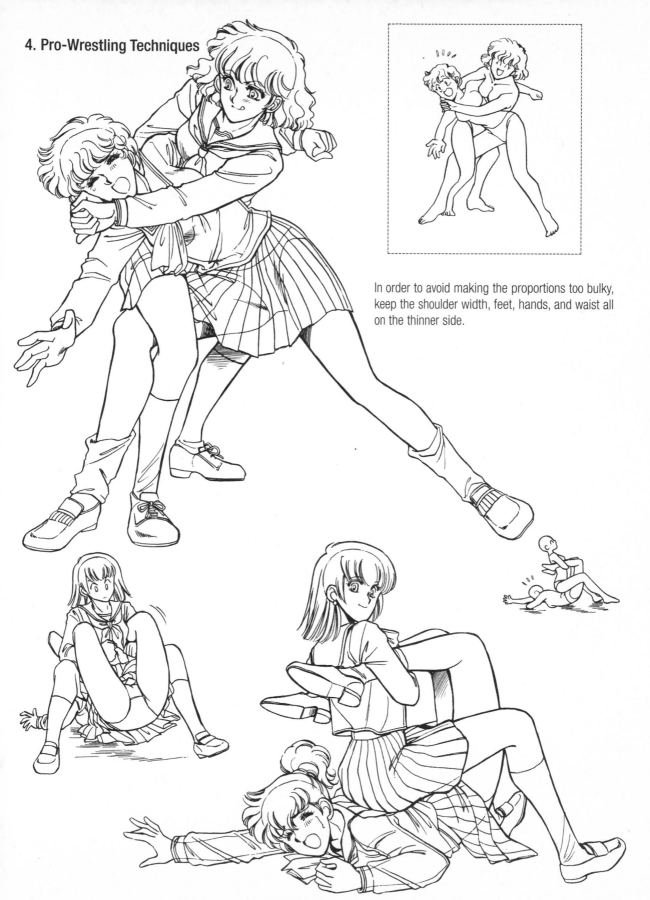

In order to avoid making the proportions too bulky, keep the shoulder width, feet, hands, and waist all on the thinner side.

For two girls with about the same build, go for balance by keeping the thickness of the arms and legs about the same.

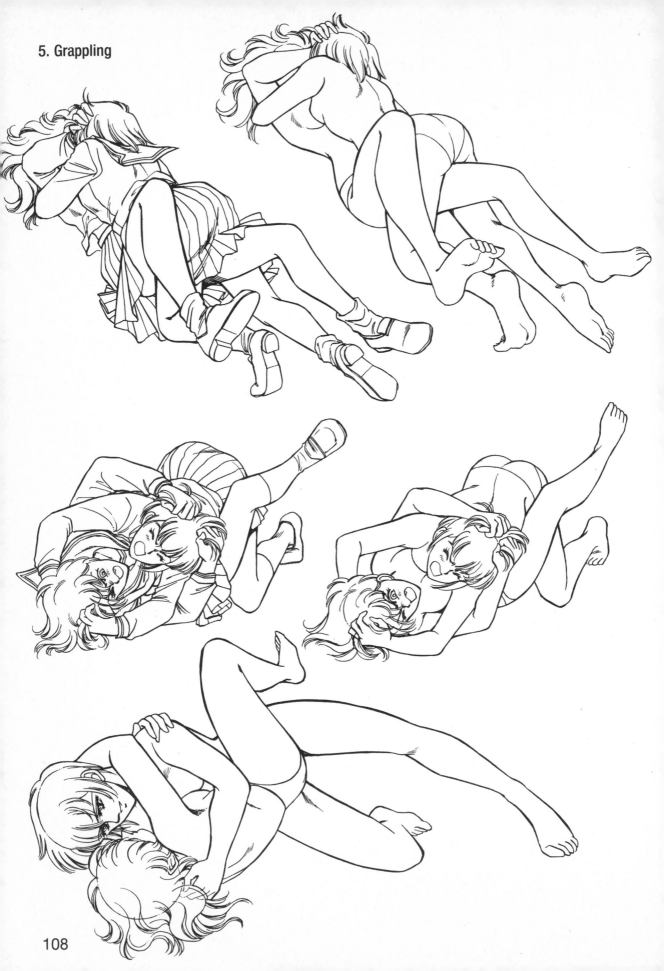

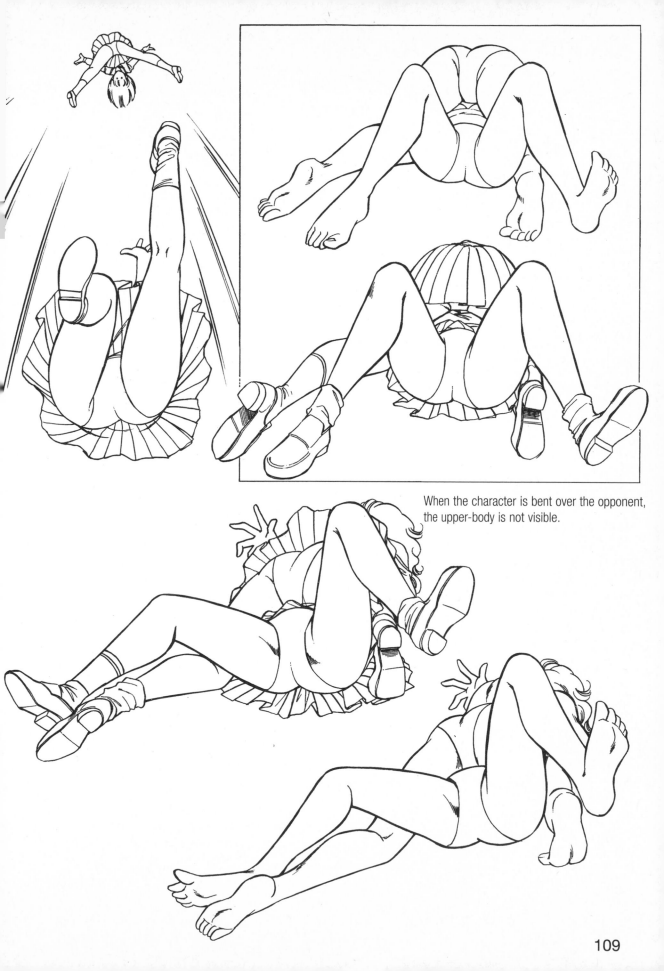

When the character is bent over the opponent, the upper-body is not visible.

# 6. Pinning Down

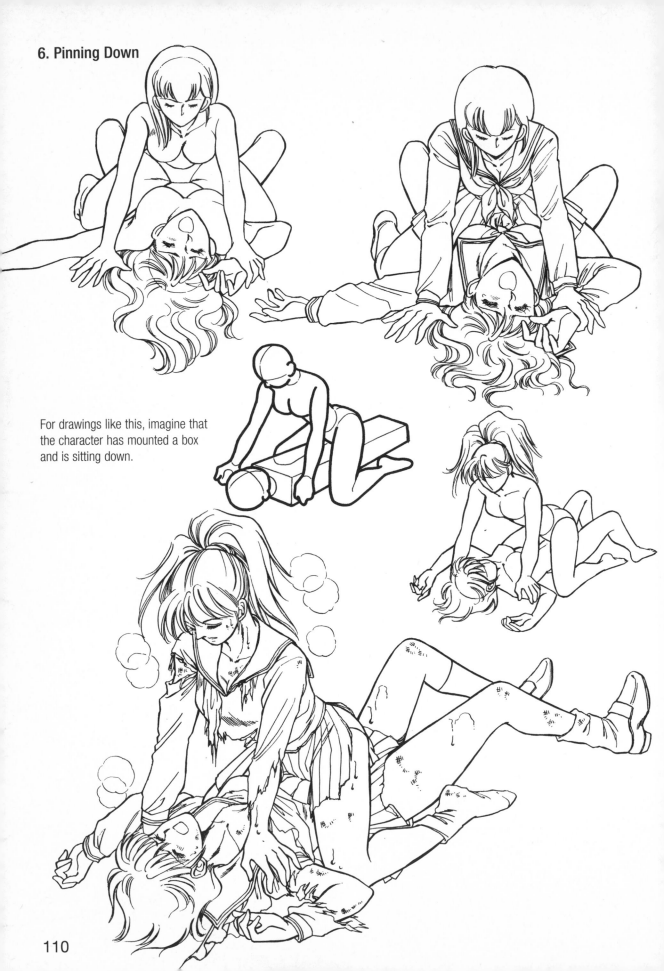

For drawings like this, imagine that the character has mounted a box and is sitting down.

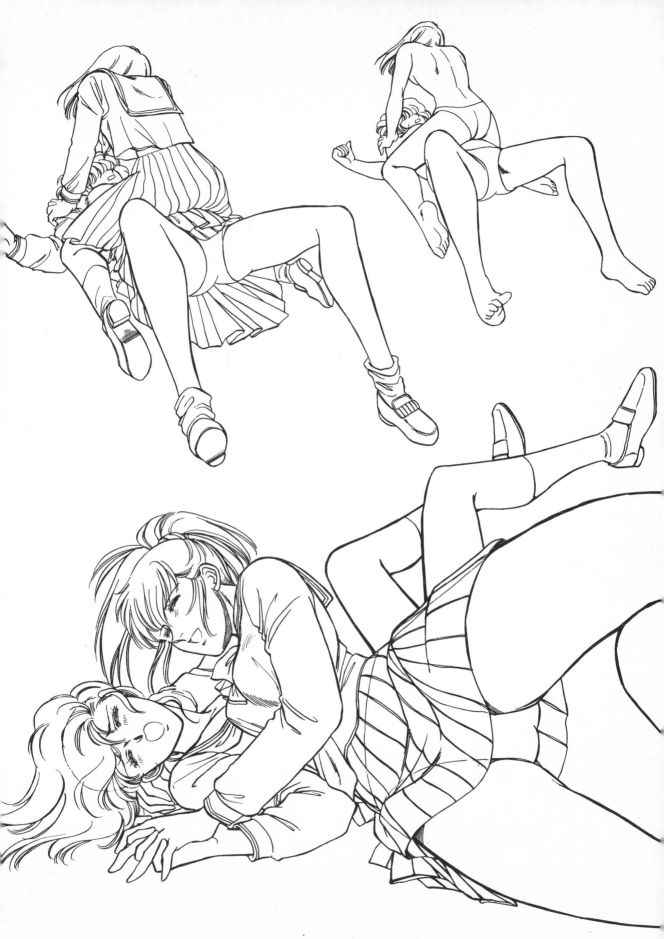

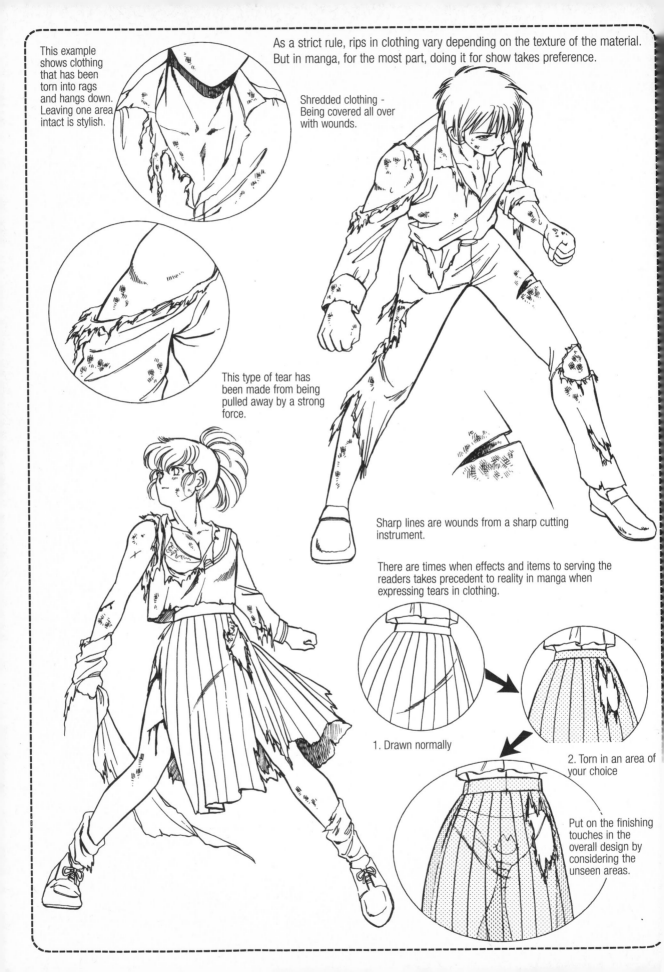

This example shows clothing that has been torn into rags and hangs down. Leaving one area intact is stylish.

As a strict rule, rips in clothing vary depending on the texture of the material. But in manga, for the most part, doing it for show takes preference.

Shredded clothing - Being covered all over with wounds.

This type of tear has been made from being pulled away by a strong force.

Sharp lines are wounds from a sharp cutting instrument.

There are times when effects and items to serving the readers takes precedent to reality in manga when expressing tears in clothing.

1. Drawn normally

2. Torn in an area of your choice

Put on the finishing touches in the overall design by considering the unseen areas.

# CHAPTER 4

# LEARN FROM THE MASTERS: MANGA ARTIST CASE STUDY TECHNIQUES

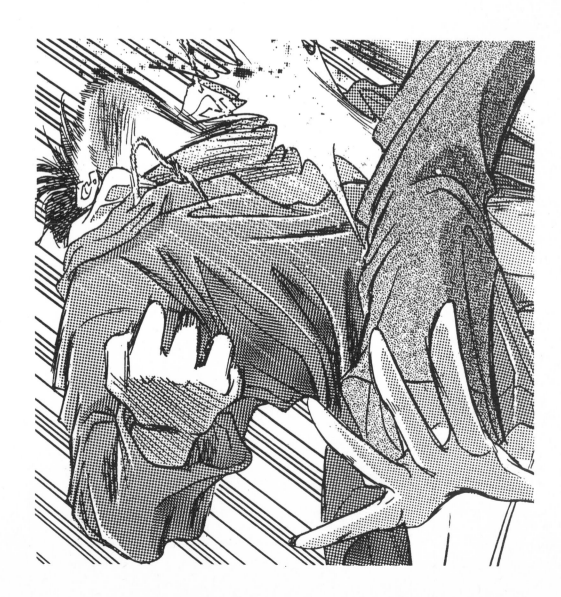

# HIIROO SANJOO (Hero Visit)

## by Kazuaki Morita

The crack along the head is from the shock of the kick. The effect of the flash style emphasizes the shock further. The tips have been sharpened showing the very nature of the moment and the power. The theory for expressing the cracks is to use thinner lines than that used for the facial outline. This creates contrast.

The distinction made with the black ink in the fat and thin lines in the mechanical quality of the one-eyed lens brings out a sense of unevenness and solidity.

The clenched fist shown above creates a sense of exertion from the character which inadvertently oozes out from such detail.

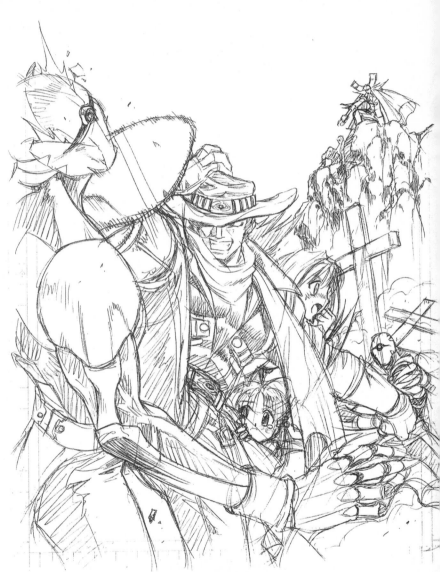

**The mightiness of a "cool" character may be shown through subtle acts implying self-composure rather than the physical attack itself**

Make an effort to design enemy characters (who later will be beaten by the main character) in such a way that they possess enough "strangeness" so that they appear unbeatable by a normal person in battle. It just wouldn't work if they are too cool nor uncool. By doing so, you convey the main character's extraordinary strength. Take note of how the artist chose to give a very natural posture for the upper-body which separates it from the facial expression along with the kick. Moreover, the bent knees of the kicking leg drawn in combination with the slightly inclined upper-body convinces the viewer of the character's superhuman powers.

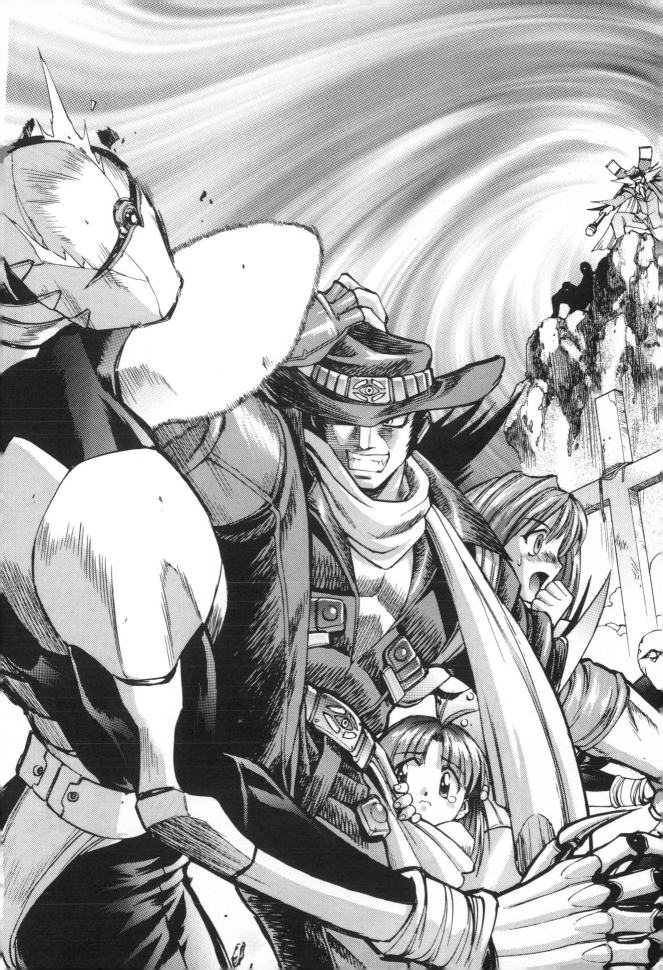

Drawing the kicking leg with oblique lines brings out the sensation of speed. Weight and powerful strength materialize by adding the hem of the slacks and the height of the shoe soles into the vision of the slanted effect lines.

Using oblique lines on selected points of the attacked character (right foot) helps create a dynamic picture wich captures the moment.

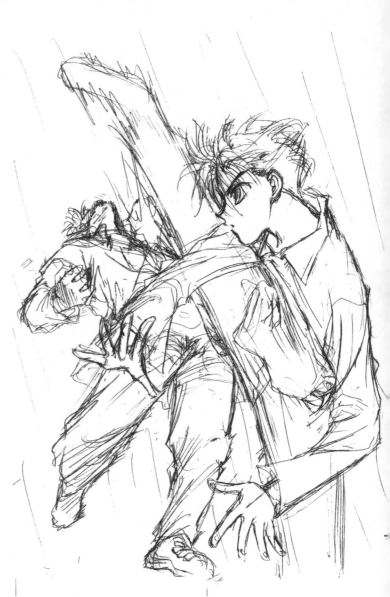

### Wild powerfulness comes about when getting away from textbook fighting techniques

The main character is positioned at a 90-degree angle from the attacked-character. While this is a standard high leg-knife kicking technique, the movement of both arms is original. When maintaining balance in the upper-body, the character simultaneously gets bigger leaving a powerful impression. The variations on the so-called forms of 'kenpo' and fighting techniques push the character's charming wildness into the spotlight. The flow of power when the kick is raised all the while keeping his sense of balance are part of the collectively calculated genesis of the effects in the aesthetics of this scene. In addition, the high-flying leg and the hit mark in the attacked-character's chest makes us imagine the moment prior to the the leg being raised. Moreover, at the same time, it brings out the powerfulness of the character in this given moment.

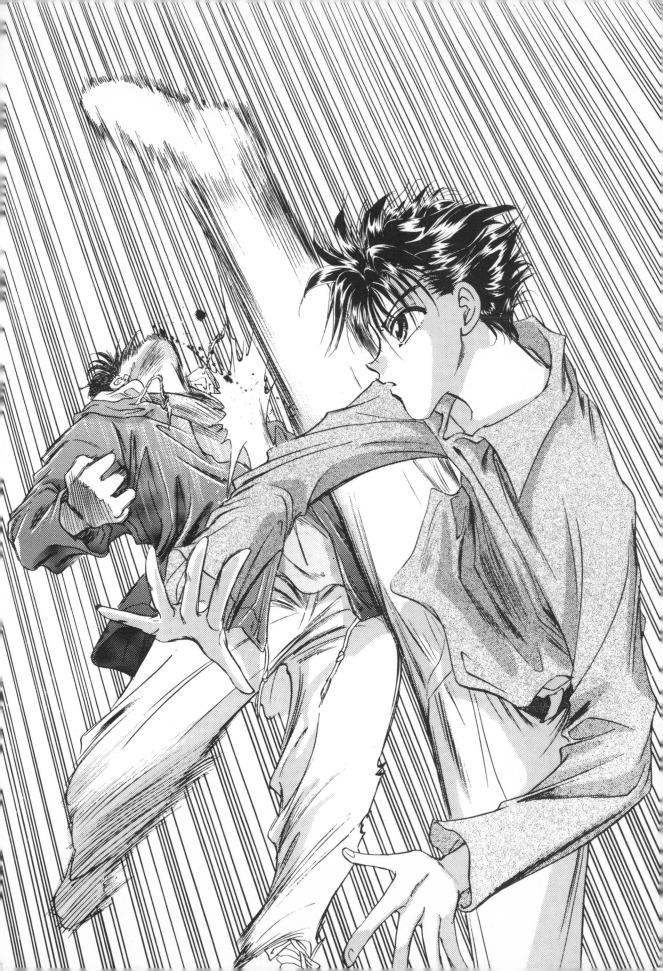

# KURU!! (Come On!!)

## by Takashi Nakagawa

Things like the shadow of the sword resting on the character's shoulder and the crossed strings on the side of the body express the delicate body lines of this female. The reality of the small details and the detailed artwork heap up a feeling of tension to the scene.

A raised leg with the heels of the sandals drawn ever so carefully. While simultaneously supporting the character's weight, it expresses the indication of the character's movement in this moment in time with a delicate feeling of stability.

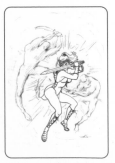

PC effects management has in due time become the main-current faction; however, the fundamentals lie in the design and composition.

### The quirkiness of PC effects comes from deformed characters and compositions

While bringing out the sense of tension and movement in the drawing above may look easy, this in fact requires highly advanced skills. The deformation was done starting with an image of a swirl with the heroine arranged in the center. Take note of how the artist had syncronized the swirling effect with the approaching enemies. This is a fine example of how having a clear vision enables one to create such marvelous enemy characters possessing sinister qualities. This type of layout urges one to stretch his/her imagination beyond ordinary boundaries.

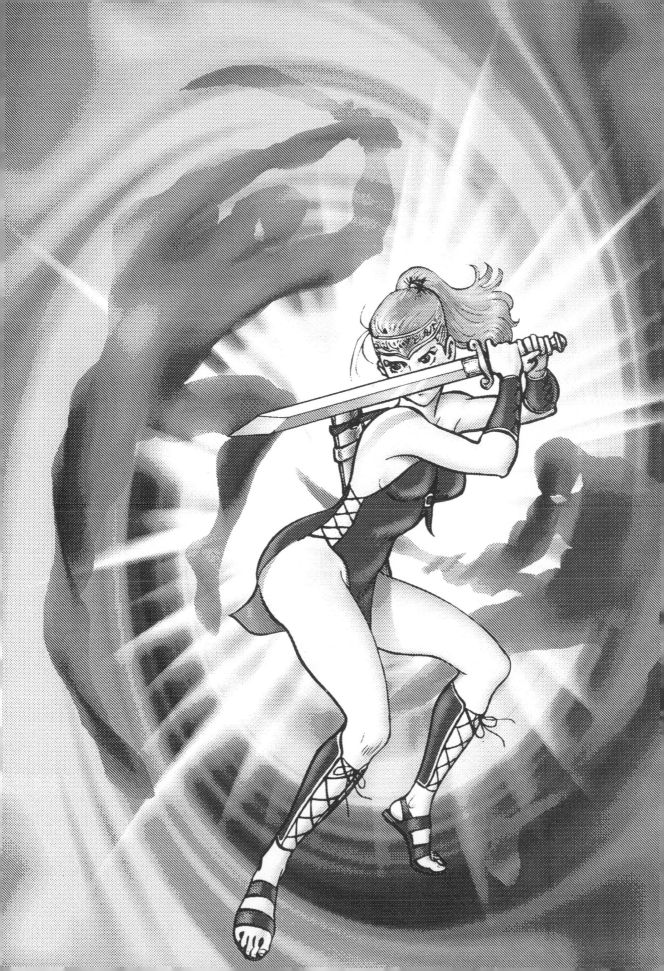

# KE•N•KA☆☆(Cat Fight)

## by Kimiko Morimoto

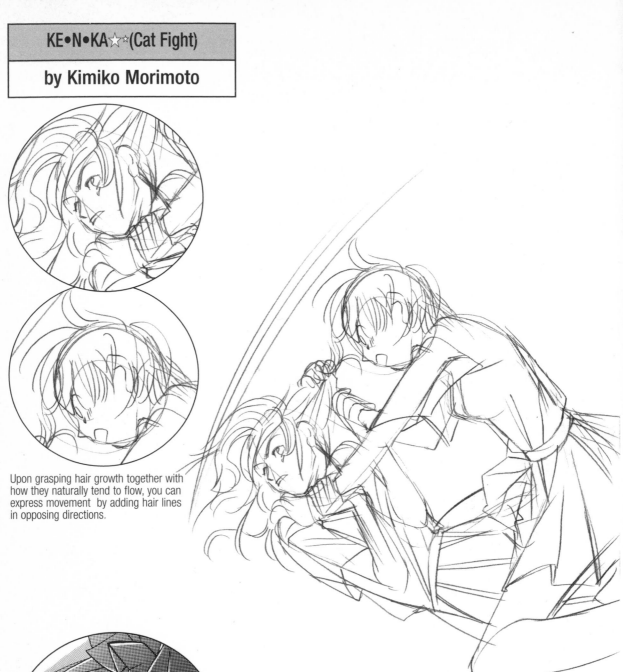

Upon grasping hair growth together with how they naturally tend to flow, you can express movement by adding hair lines in opposing directions.

Even with thin legs, the muscle lines are well based on the frame of the body. The well-tailored fundamental drawing conveys a sense of weight and existence.

### Incorporating contrast in a well-tailored drawing results in a dynamic picture

Observe the skirt of the girl on top. Notice how portions of it are tucked in between her legs while other parts straddle over the girl on the bottom. This contrast helps bring out the moment she mounts the other girl. Moreover, avoiding commercially effective 'panty shots' gives credibility to the struggle. In the meantime, a sense of existence is emphasized through casting shadows solely on the characters. The artist's choice in keeping everything but the skirts white creates an overall contrast with the dark, eerie background made through the use of a patting technique often used to create a dreamlike atmosphere. The contrast directed in this battle scene lies not so much in the physical force but in the psychologial intensity.

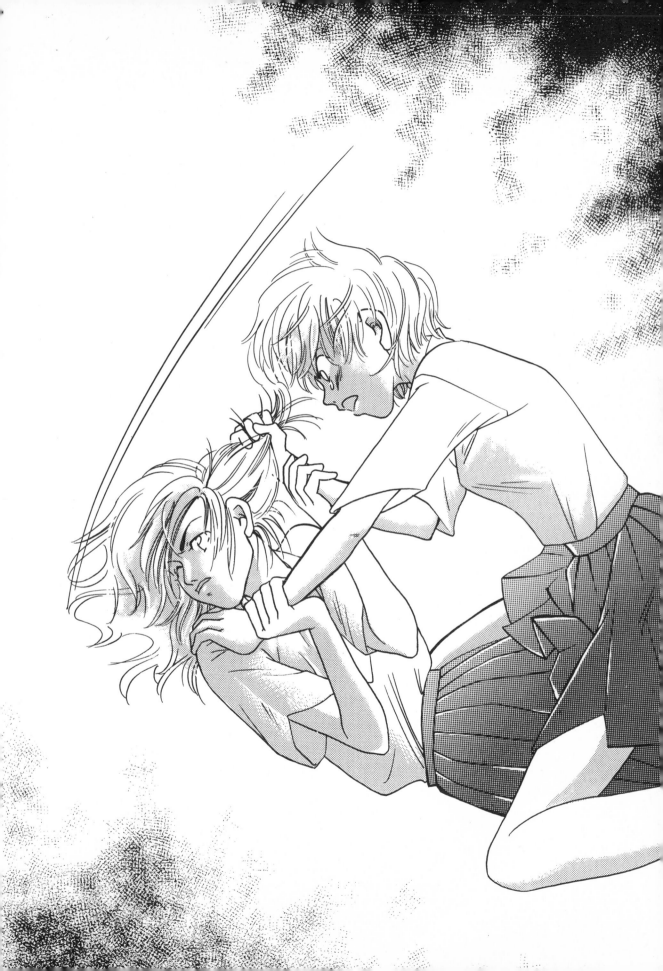

## Fight!

### by Takehiko Matsumoto

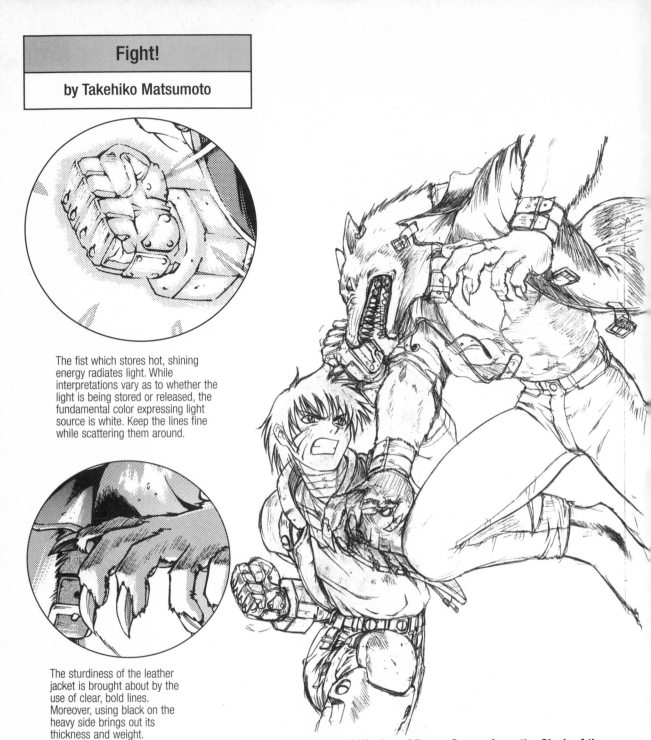

The fist which stores hot, shining energy radiates light. While interpretations vary as to whether the light is being stored or released, the fundamental color expressing light source is white. Keep the lines fine while scattering them around.

The sturdiness of the leather jacket is brought about by the use of clear, bold lines. Moreover, using black on the heavy side brings out its thickness and weight.

**The Cohesion of Battle and Diffusion of Power Comes from the Clash of the Characters Placed Diagonally from One Another**

The diagonal placement of the two opposing characters gives birth to an intensity gushing with fierceness in the center of the picture. While the character on the lower left twists his body in order to dodge the enemy's attack, his body simultaneously shifts in a right angle facing his opponent with his waist wound up, implying his readiness to deliver a terrific blow. Such knowledge and experience in the mechanism of throwing punches along with the skillful maneuvering of the body comes in handy when expressing realistic fight scenes. Notice how the shadows cast on the bodies through the use of tones unfold from the radiant fist of the young boy. The same applies to the lightning bolts as well as the background. By composing the power towards the center while visually directing the light at the lower left corner as the focal point, the illustration bestows a sense of three-dimensional activity.

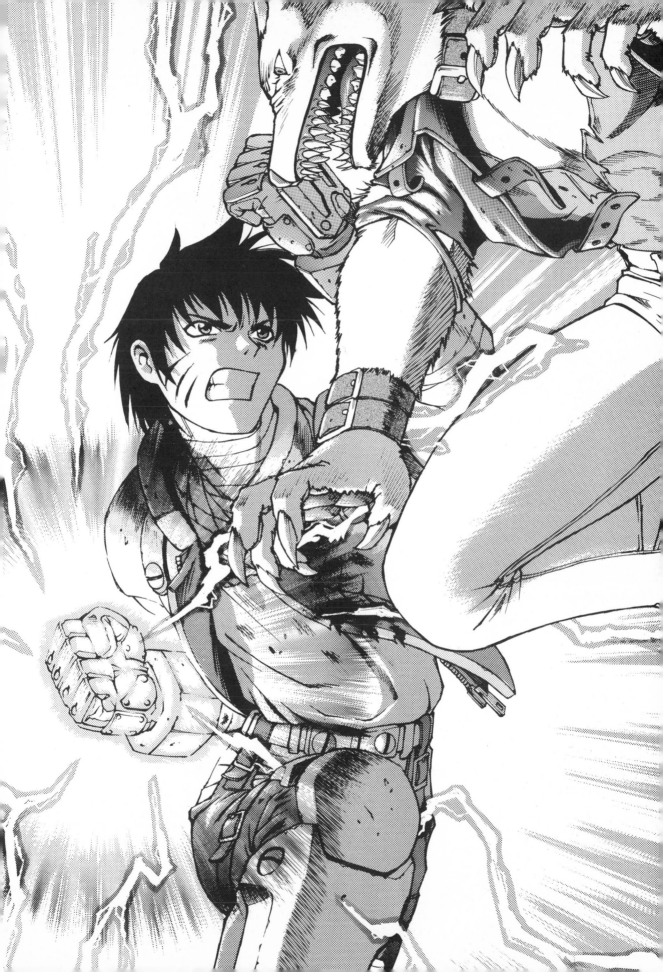

# PAIRUDORAIBAA (Pile-Driver)

## by Kunichika Harada

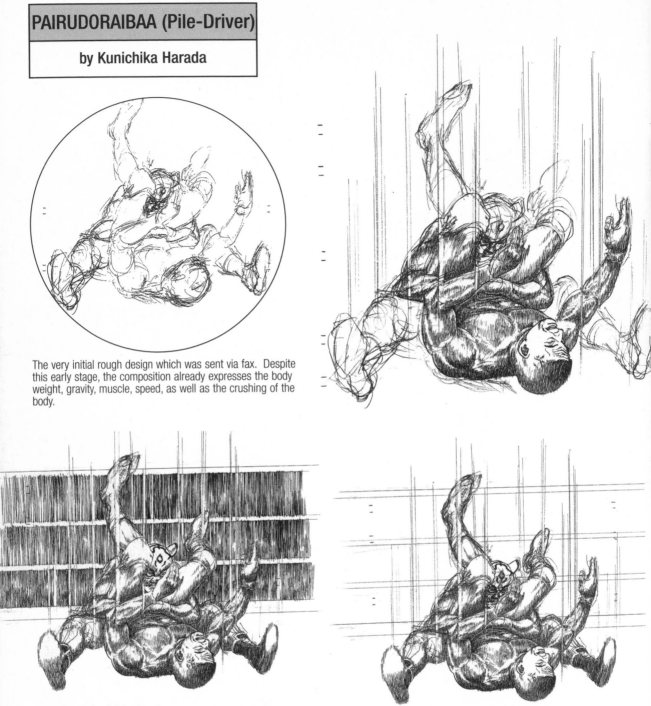

The very initial rough design which was sent via fax. Despite this early stage, the composition already expresses the body weight, gravity, muscle, speed, as well as the crushing of the body.

Just prior to the finished work

## Muscle & Weight, Speed & Gravity are Jammed into the Body.

One of the keys to creating intensity is contrasting shadows. While the first, finely drawn, vertical oblique lines are conscious of the direction and momentum of the drop, the second oblique lines used on the body itself, when combined with the white sections hit by light, brings the well-hardened bodies into relief. Moreover, the well-balanced drawing of the masked wrestler comes as a result of the artist fully incorporating both the visible (head, arm & shoulder, widely spread legs) and the invisible body parts (thick chest & rounded back). Such ability to take both seen and unseen parts into account results in the weight and thickness of the muscles to come alive. As for the dropped character, the key to expressing the moment his arms and legs relinquish power lies in the subtle angling of his joints. In conclusion, powerful compositions are achieved through combining the layer of individual viewpoints atop that which sees the two bodies as one whole unit.

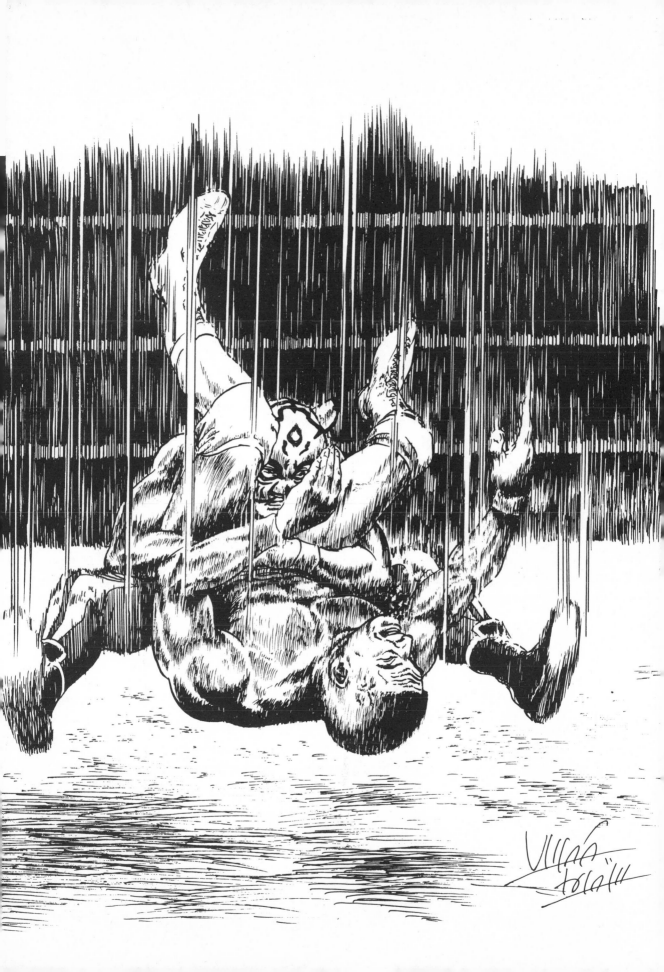

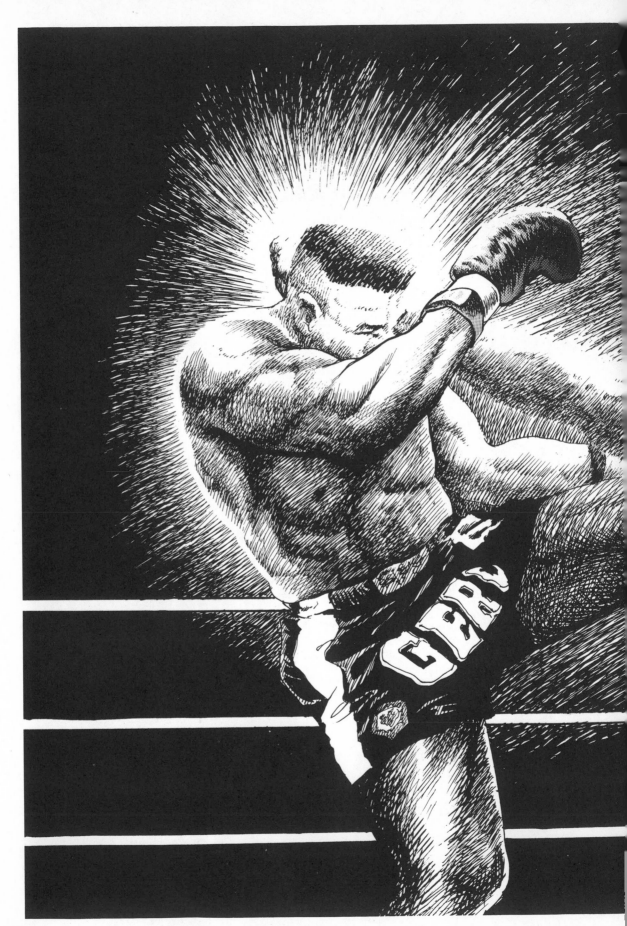

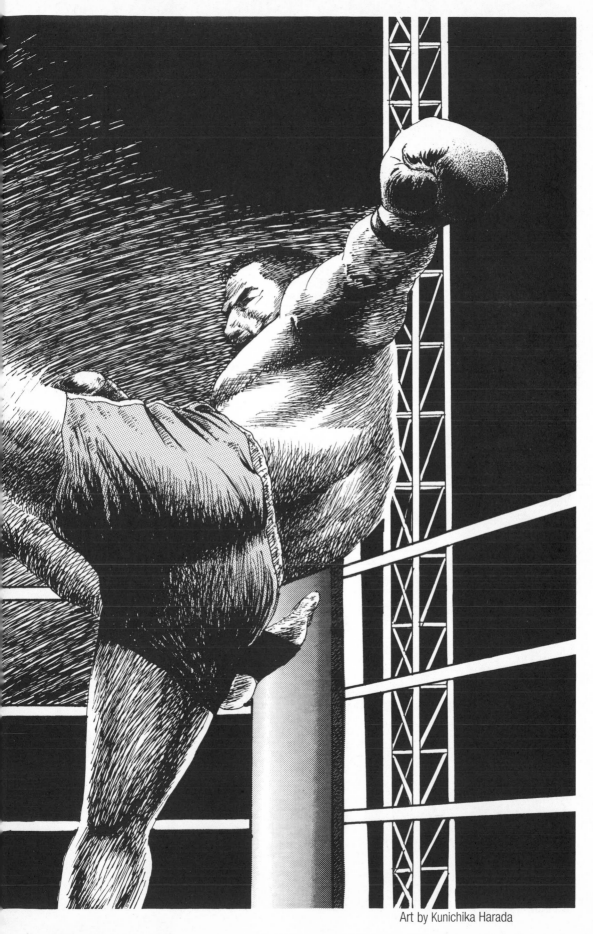

Art by Kunichika Harada

Author Profile

# Hikaru Hayashi

Born in Tokyo.
Graduated from Tokyo Metropolitan University, Bachelor of Arts in philosophy.

1987    Awarded the Encouragement Prize and Fine Work Award in the <u>Business Jump</u> competition
        (Shueisha Inc.). Worked as an assistant to Hajime Furukawa.
1989    Became Noriyoshi Inoue's pupil at <u>Weekly Young Jump</u> (Shueisha Inc.).
1992    Debuted with a historical account of the 'Aja Kong Story' printed in <u>Bears Club</u> (Shueisha Inc.).
1997    Established Go Office, a manga design production office.
1998    Techniques for Drawing Female Manga Characters (part of the How to Draw MANGA Series),
        How to Draw MANGA: Boys, How to Draw MANGA: Couples, How to Draw MANGA:
        ILLUSTRATING BATTLES.
1999    How to Draw MANGA: BISHOUJO Around the World, How to Draw MANGA: BISHOUJO -
        Pretty Gals, How to Draw MANGA: OCCULT & HORROR and How to Draw MANGA: More
        About Pretty Gals - all published by Graphic-sha Publishing Co., Ltd.